First published in the United States of America by:
Rockport Publishers, Inc.
33 Commercial Street
Gloucester, Massachusetts 01930-5089
Telephone: (978) 282-9590
Facsimile: (978) 283-2742

Distributed to the book trade and art trade in the United States by:
North Light Books, an imprint of
F & W Publications
1507 Dana Avenue
Cincinnati, Ohio 45207
Telephone: (800) 289-0963

Other Distribution by:
Rockport Publishers, Inc.
Gloucester, Massachusetts 01930-5089

ISBN 1-56496-374-8
10 9 8 7 6 5 4 3 2 1
Selected and edited by Joyce Rutter Kaye
Designer: Monty Lewis

Printed in Hong Kong by Midas Printing Limited.

graphicidea
resource

Joyce Rutter Kaye

ROCKPORT
PUBLISHERS

Rockport Publishers, Inc.
Gloucester, Massachusetts
Distributed by North Light Books
Cincinnati, Ohio

CHRISTIANSEN FRITSCH GIERSDORF GRANT AND SPERRY INC.

DAVID GIERSDORF

 is the essence of graphic communication. When a typeface is carefully selected and skillfully used, it can enhance the meaning of the written word and communicate a message instantly and effectively to the intended audience. Conversely, when a typeface is mismatched to a project, the results can have a opposite effect, ranging from the banal to the downright illegible.

The last ten years have seen an explosion in the creation and distribution of digital typefaces. Once the province of a handful of large type foundries, the type industry has grown to include hundreds of small type design studios creating and marketing their own niche products. The demand for typefaces has also grown tremendously, with the explosion of desktop publishing technology and the growth of home office businesses. While most graphic

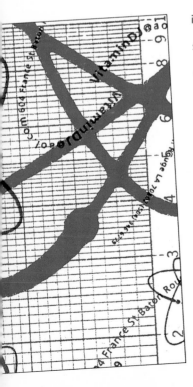

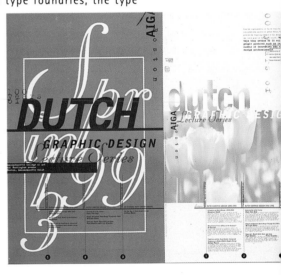

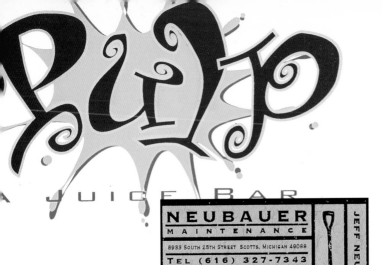

designers were once happy to rely on a core group of favorite classic typefaces and a

handful of display designs, they now have tens of thousands to choose from for their

projects. The range of choices can be daunting, but it is also inspiring. One need not look

far to find an edgy display face for a snowboard product aimed at Gen X-ers, or an elegant

version of Bodoni for a limited edition book.

This book features ninety examples of creative, innovative, and appropriate uses of type

in projects ranging from business cards to brochures to self-promotional mailers. Some

projects may use a beautiful script letter as a central element in the design, while others

take a more subtle, understated approach, using a carefully selected, classic sans serif

style. Whatever the choice, these projects reveal a love of letters–

and a sensitivity to the message at hand.

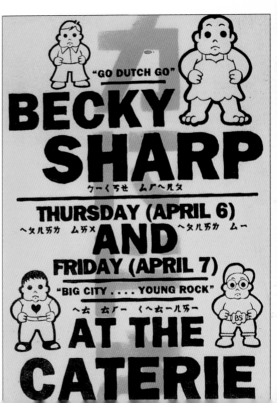

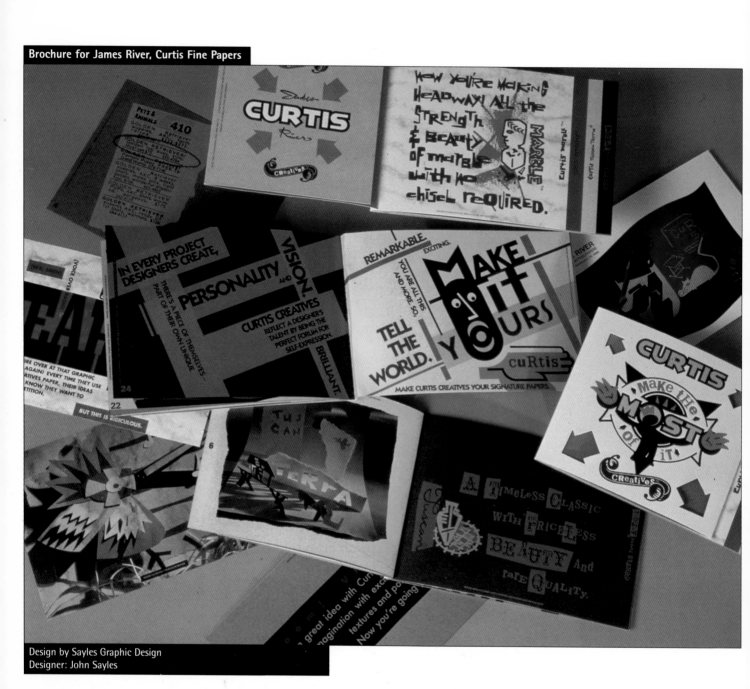

Design by Sayles Graphic Design
Designer: John Sayles

To promote Curtis Fine Papers as being the ultimate vehicle of self-expression, John Sayles incorporated a variety of provocative display faces in this promotional piece for James River.

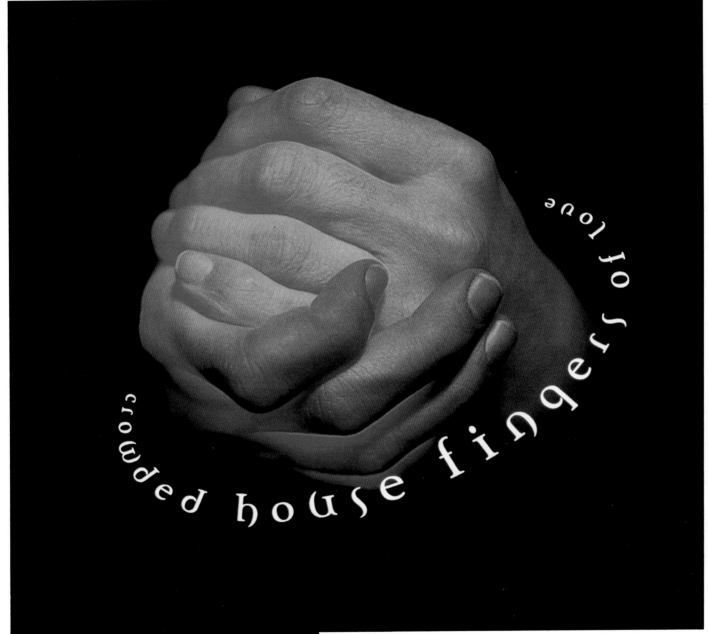

crowded house fingers of love

Design by Margo Chase Design
Art Director/Designer: Margo Chase
Photographer: Sidney Cooper

Los Angeles designer Margo Chase selected Envision, her own curvy font, to wrap text around the global sphere created by clasped hands for this CD design for pop group Crowded House.

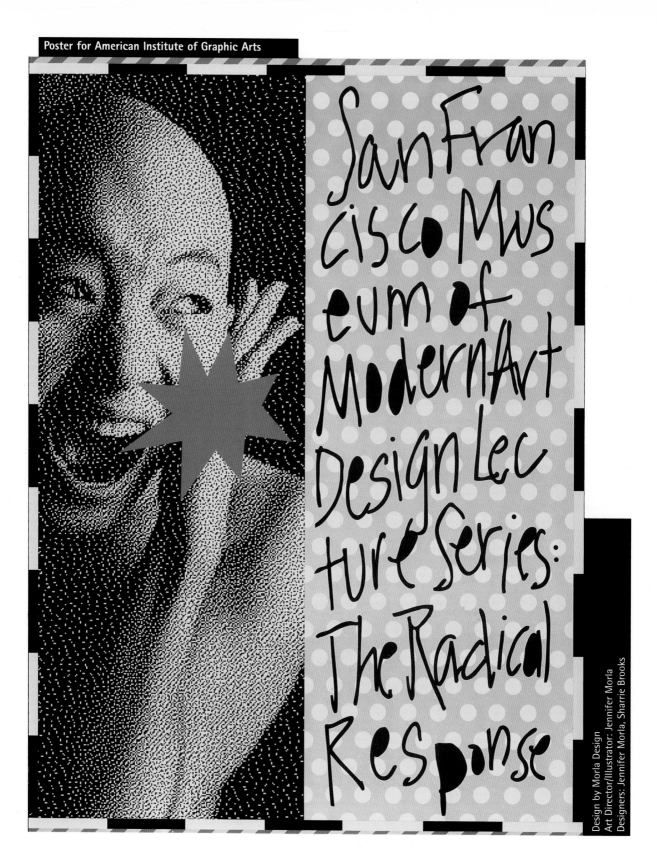

San Fran cisco Mus eum of Modern Art Design Lec ture Series: The Radical Response

Design by Morla Design
Art Director/Illustrator: Jennifer Morla
Designers: Jennifer Morla, Sharrie Brooks

The use of a scrawl-like handwritten font emphasizes the radical aspect of this museum lecture series on design issues and lends an immediacy and urgency to the message.

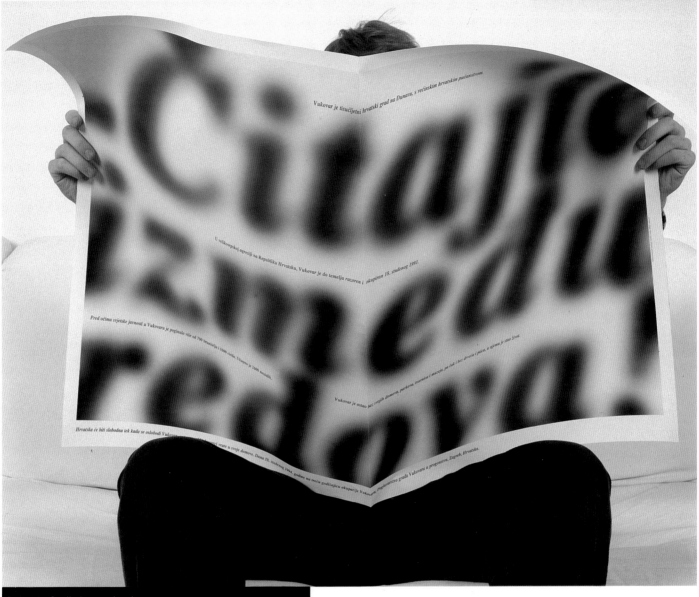

Design by Studio International
Designer: Boris Ljubicic
Photographer: Damir Fabijanic

This political poster from Studio International takes a literal spin on a well-known metaphor. Each side uses blurry, greatly enlarged type to command readers in English and Croatian to "read between the lines"; when they do, they learn of the forced occupation of the Croatian town of Vukovar in 1991.

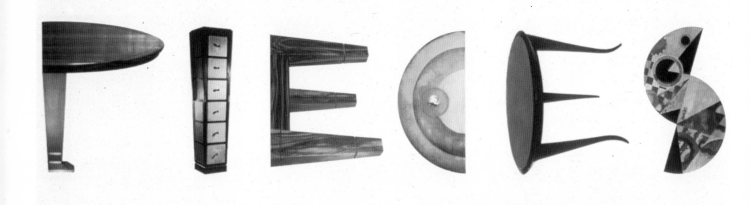

Design by COY
Art Director: John Coy
Designers: John Coy, Rokha Srey

With wit and style, COY Design turns the tables on its custom furniture client by spelling out the retailer's name using furniture and a computer font in this identity package.

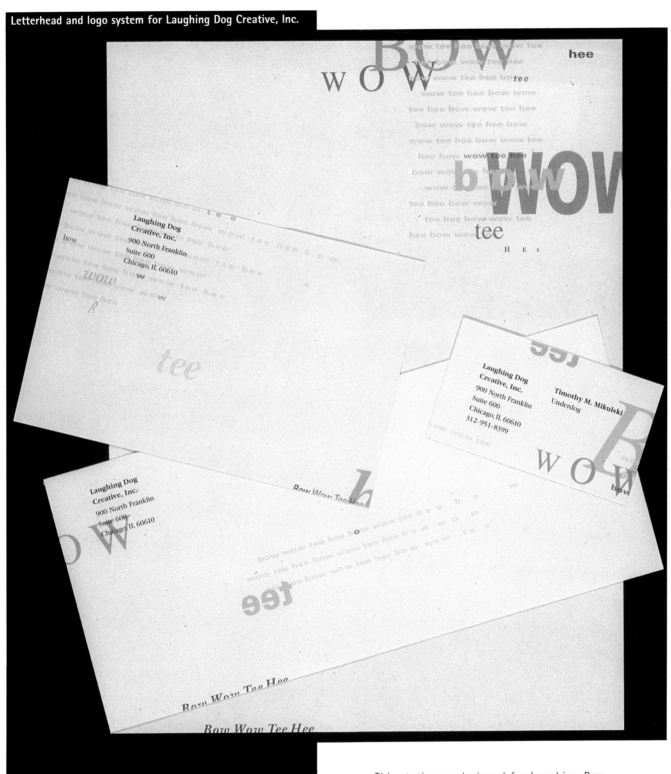

Design by Laughing Dog Creative, Inc.
Art Director: Frank EE Grubich
Designer: Joy Panos

This stationery designed for Laughing Dog Creative incorporates the words "tee-hee" and "bow-wow," set in varying sizes of overlapping serif and sans serif type, for a playful effect.

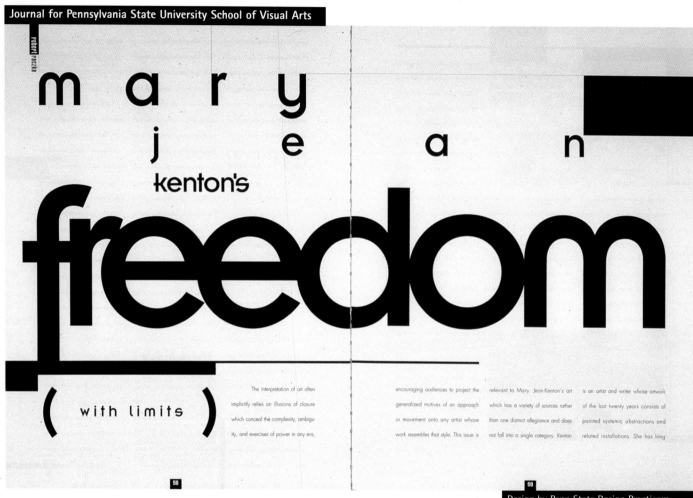

Journal for Pennsylvania State University School of Visual Arts

robert packie

m a r y

j e a n

kenton's

freedom

(with limits)

The interpretation of art often implicitly relies on illusions of closure which conceal the complexity, ambiguity, and exercises of power in any era,

encouraging audiences to project the generalized motives of an approach or movement onto any artist whose work resembles that style. This issue is

relevant to Mary Jean Kenton's art which has a variety of sources rather than one distinct allegiance and does not fall into a single category. Kenton

is an artist and writer whose artwork of the last twenty years consists of painted systemic abstractions and related installations. She has long

58

59

Design by Penn State Design Practicom
Art Director: Lanny Sommese
Designers: Scott Patt, Brett M. Critchlow

The cover design and layout treatment for the Penn State *Journal of Contemporary Criticism* eschews the usual staid academic journal format by taking a more graphic approach, with layouts using contemporary sans serif typefaces and abstract black-and-white type treatments to emphasize content.

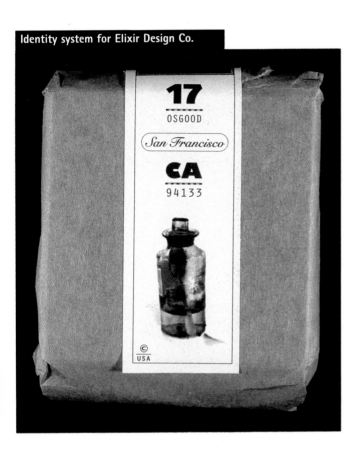

Identity system for Elixir Design Co.

17
OSGOOD
San Francisco
CA
94133

© USA

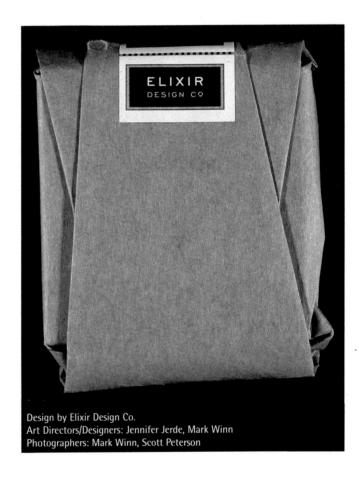

ELIXIR
DESIGN CO

Design by Elixir Design Co.
Art Directors/Designers: Jennifer Jerde, Mark Winn
Photographers: Mark Winn, Scott Peterson

Elixir Design in San Francisco has an affinity for metal
typefaces, letterpress printing, and tactile paper. This
self-promotion piece plays off the company name with a
mailing label showing an image of pharmaceutical bottle
complemented with text set in a range of metal
typefaces.

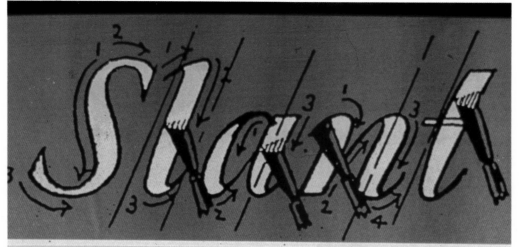

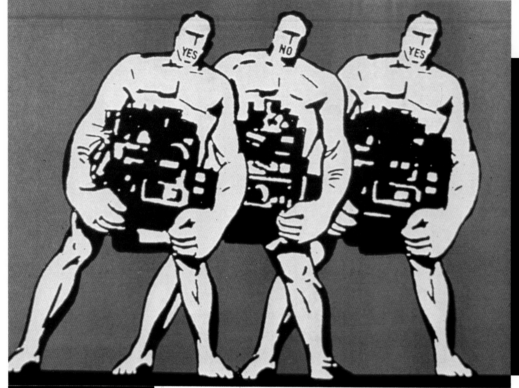

Slant **newspaper design**

Design by Urban Outfitters
Creative Director/Editorial Director/Typography: Howard Brown
Art Directors: Howard Brown, Art Chantry
Designer: Art Chantry

An old-fashioned lettering instruction book
provided the inspiration for Howard Brown's logo
design for Slant, a tabloid newspaper published
quarterly by retailer Urban Outfitters for their
young, trend-conscious customers.

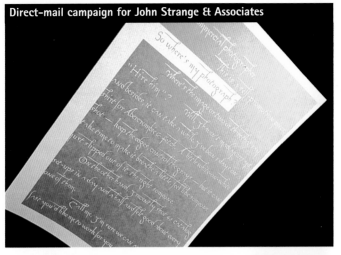

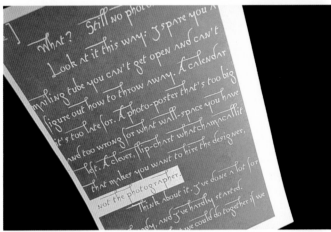

To help a new photography studio launch its business, design firm Schmeltz & Warren avoided showing photographs altogether, instead opting for a more elegant solution for these letters sent to prospective clients. Although the text of the letters was frank in its appeal for business, the use of a graceful, calligraphic script helped lend an ironic twist.

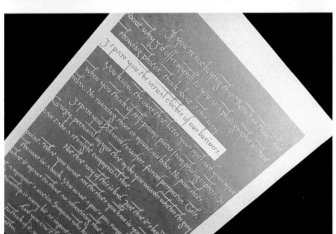

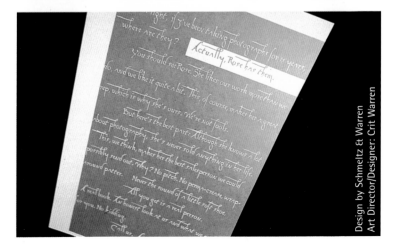

Design by Schmeltz & Warren
Art Director/Designer: Crit Warren

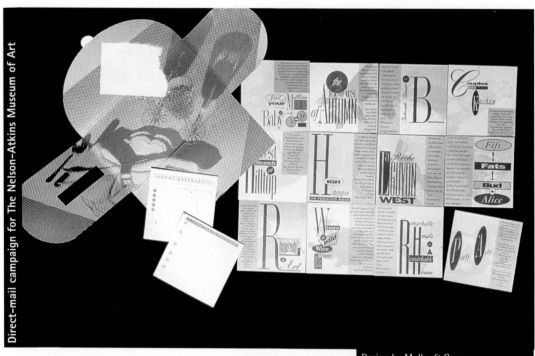

Design by Muller & Company
Art Director: John Muller
Designer/Illustrator: Peter Corcoran

This mailer for a museum used twelve cards, each describing a fund-raising event. To make each one stand out, drop caps were selected for key words to emphasize unique aspects of each occasion, while text was poured in ragged columns to the right or left.

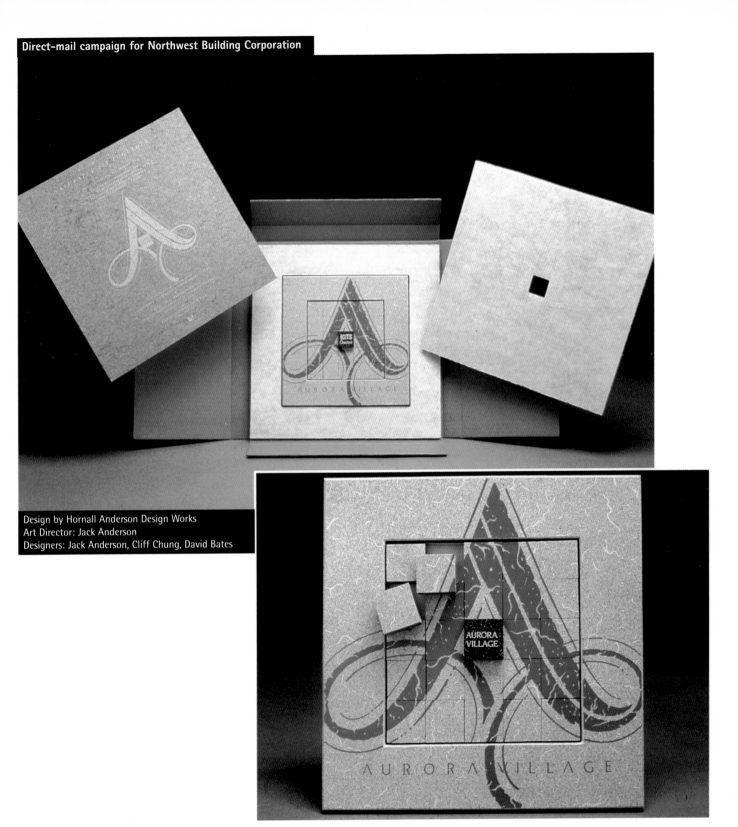

Design by Hornall Anderson Design Works
Art Director: Jack Anderson
Designers: Jack Anderson, Cliff Chung, David Bates

A new identity for a shopping center was mailed to
prospective tenants in the form of a puzzle that
incorporated the Aurora Village logo. The stylized *A*, which
when viewed upside down, can be seen as an equally
distinctive letter *V*.

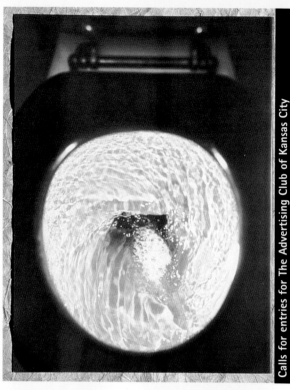

For this series of calls for entry to the Kansas City Advertising Club's 1994 Omni Awards, the typeface of choice was Courier, a typewriter-like font that adds an edgy immediacy to the copy, which humorously portrays the bathroom as being the center of all creative activity. Type was set in reverse, and plumbing-related words such as "flow" and "flushed" were called out in larger point sizes.

It's a pretty safe bet that if you're going to make it in the creative business, you're going to need to come up with good ideas. And on a regular basis.

To accomplish that, you'll need a place where you can get away from the more mundane aspects of advertising and design... the meetings, the project requisitions, the meetings, the press checks at three in the morning, the meetings, the presentation skills seminars, the meetings, the time sheets, oh, and lest we forget, the meetings.

You need a place where you can think. A place where both sides of your brain can say "Howdy," get to know each other, intermingle, share intellectual high fives, if you will; while you pretty much just keep out of the line of fire and let the creative process happen. Better yet, this place would be able to somehow keep your conscious mind occupied, in order to allow your unconscious mind to put all the pieces together in a new way, to solve the creative problem without distractions or interruptions.

Now, if you were to design such a place, exactly what would it be like? It would probably be white, to suggest openness, freedom of association, limitless possibilities. It would absolutely need to be quiet, so that nothing would disturb your oh-so-delicate thought process. It would hopefully feature walls and fixtures fabricated to be easily wiped clean, so that you could always start fresh, as it were, repeatedly and regularly. Last but not least, to maintain your stream of consciousness, you would insist upon an endless flow of fresh, clean, cool and revitalizing water.

In addition to these basic parameters, of course, your special place will also need something to make it a place you can call your own. Whether it's your back issues of Guns and Ammo, the best of The Far Side, or just a 2' x 3' throw rug from Pier 1, a little personality goes a long way toward transforming a room from merely functional to purely personal.

There now. You've got the place. You've got the assignments. Now, it's simply a matter of letting it happen. Just remember, when you emerge, flushed with pride, with the killer ideas you developed inside your special place, there's still one more step to take before you can get recognized for all your labors.

You need to enter your work in the 1994 Omni Awards.

Design by Muller & Company
Art Director/Designer: John Muller
Photographer: Dan White, Mike Regnier, Hollis Officer, Nick Vedros, Dave Ludwigs, Darryl Bernstein, Steve Curtis

Photographer Hollis Officer, and his assistant/model, Eric Bell, used a Mamiya RZ camera with Ilford film. He shot the photos at 1/8th and 1/125th of a second. Front and Back Cover

Photographer Dan White, of White & Associates, and his assistants Aaron Bales and Lisa Correu (who also supplied the gams), used a Cannon F-1 camera with a 20 mm lens, and T-MAX film. He used incandescent light in both pictures with different lights inside the bathroom. He also processed the film in a dektol solution. Grand Emporium Musicians' Bathroom

Photographer Nick Vedros and his assistant, Mike McCorkle, had the help of Dale Frommelt to design and build the set for The Dog Bone Lounge. They used a Sinar Bron 4 x 5 camera with T-MAX 100 film, and Comet and Broncolor lighting. The photos were printed on Ilford multigrade paper. Dog Bone Lounge

Photographer David Ludwigs, and his assistant, Kelly Rogers, had the help of stylist, Elaine Hazlett. They used a Mamiya RB67 camera with T-MAX 100 film and a Comet strobe. They used a 37 mm fisheye lens and diffusion printing on the toilet photo. We would like to thank the Kelly Brothers of Kelly's Westport Inn for the use of their bathroom. Kelly's Westport Inn

Photographer Steven Curtis, used a Hasselblad camera with Kodak TRI-X film. He shot at 1/125th of a second at F2.8. He also used a special dektol processing technique. Old St. Peter's

Photographer Michael Regnier, used an antique Korona 11x14 camera (built in 1900) with Super XX film and tungsten lighting. He used the film to make a contact paper negative, and used that to make a contact print on Oriental fiber base paper. Liebstadter Millinery

Photographer Darryl Bertstein, used a Hasselblad camera with T-MAX 100 film and a hand held clamp light. For the photo at the American Royal, he faced death by placing his light in the inside rim of the toilet. Wayne's Harley Grand Emporium Savoy Grill American Royal

This call for entry theme was adapted from an original concept created by Muller+Company for Dix & Associates.

Creative: Muller+Company. Paper: Midwestern Paper Company. Printing: Tenth Street Printing Company. Typesetting: Fontastik Inc. Separations: Cicero Graphic Resources Inc, Superior Color Graphics, Chroma-Graphics Inc., Trans America Color Systems.

The German
words for

thirst *(durst)*

and silence

(stille) are

graphically

connected

with a

diagonal line

of copy that

shows the

progression

of spiritual

advancement

offered by a

session of

meditation.

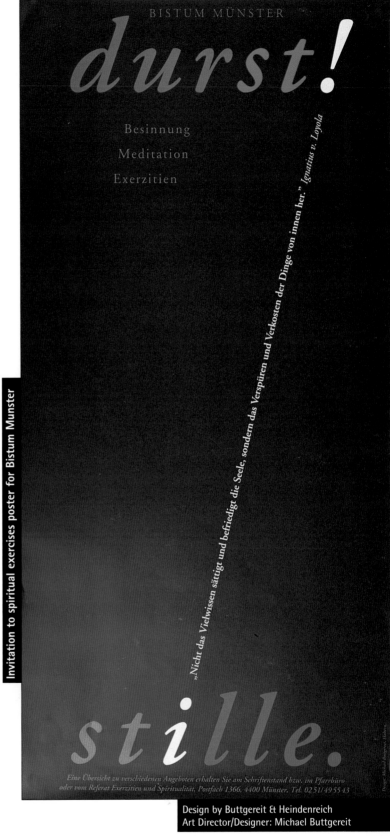

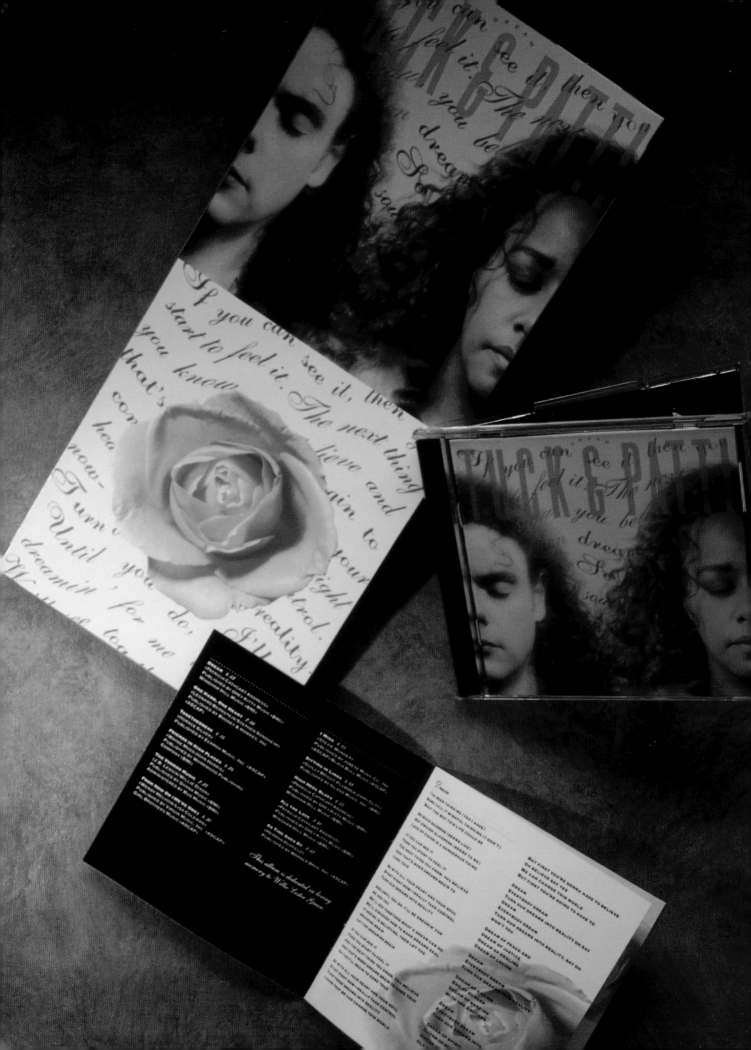

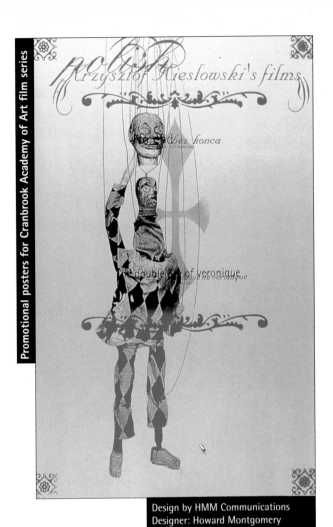

Promotional posters for Cranbrook Academy of Art film series

Design by HMM Communications
Designer: Howard Montgomery

A poster for a film series featuring the works of
Polish director Krzysztof Kieslowski creates intrigue
with a central image of a two-headed marionette
enhanced with a title presented in layers of
flourished script type and early twentieth-century
corner ornaments.

Packaging for Tuck & Patti compact disc

Design by Morla Design
Designers: Jeanette Aramburu, Jennifer Morla

Morla Design's compact disc packaging for
a Tuck & Patti release entitled *Dream*,
creates a surreal mood with sepia-toned
images of the somnolent duo with lyrics
of the title song set in curved lines of
romantic script.

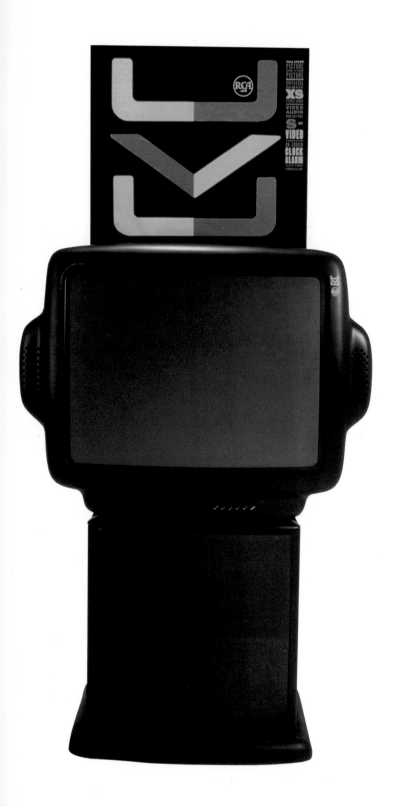

Packages, T-shirts, and other printed pieces for RCA's UVU television were designed by Paula Scher and Ron Louie of Pentagram Design with bold, abstract initial letters and a black-and-orange color scheme for a high-impact and high-contrast effect.

UVU television boxes

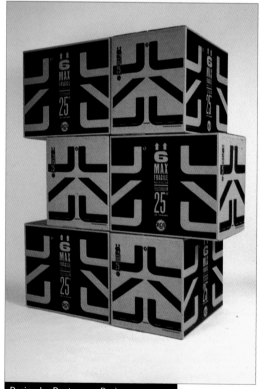

Design by Pentagram Design
Designers: Paula Scher, Ron Louie

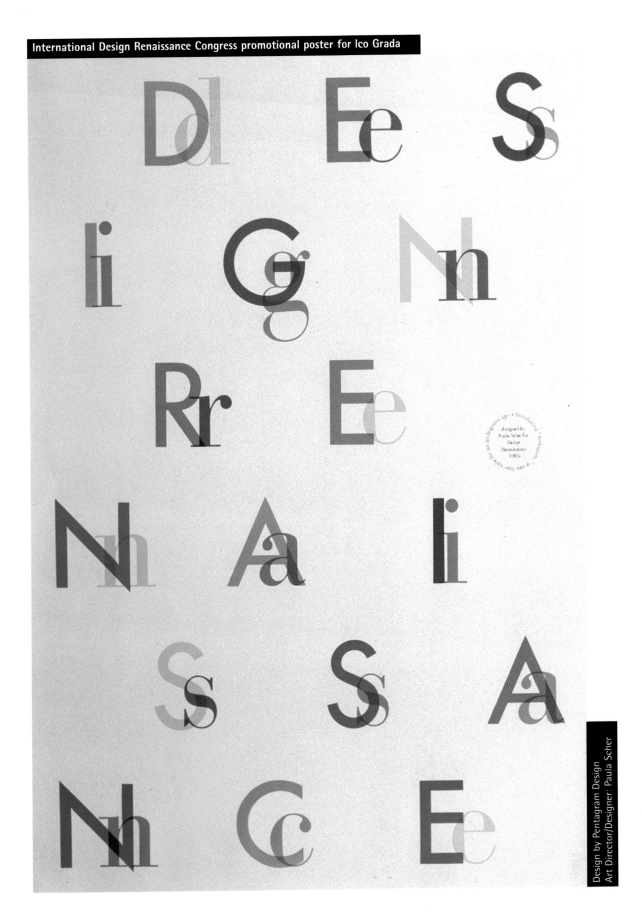

Design by Pentagram Design
Art Director/Designer: Paula Scher

Paula Scher's signature style is a bold, expressive use of letterforms. For this poster promoting the International Design Renaissance Congress, she superimposed uppercase Helvetica letters with lowercase Bodoni, suggesting the commingling of two eras of design.

To promote the Independent Project Press' library of typefaces and ornaments, Bruce and Karen Licher printed this catalog on their own Vandercook letterpress with typefaces that reflect their affinity for wood and metal typeface revivals.

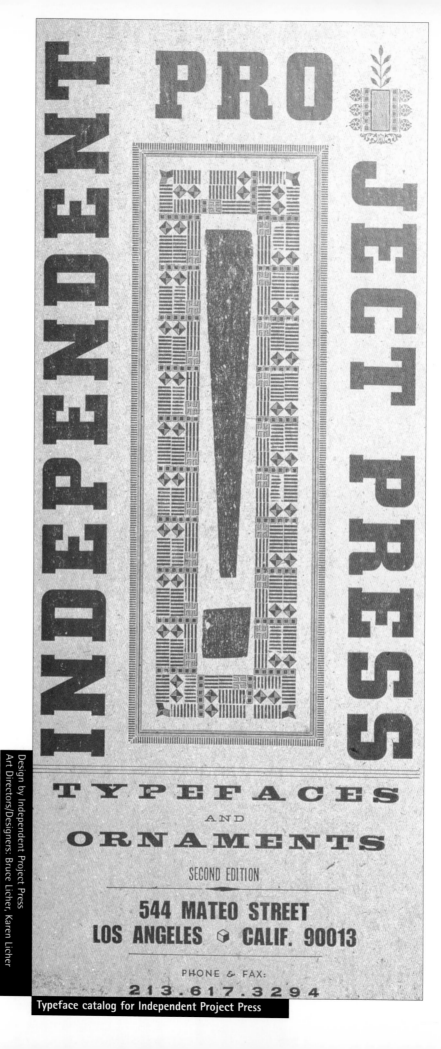

Typeface catalog for Independent Project Press

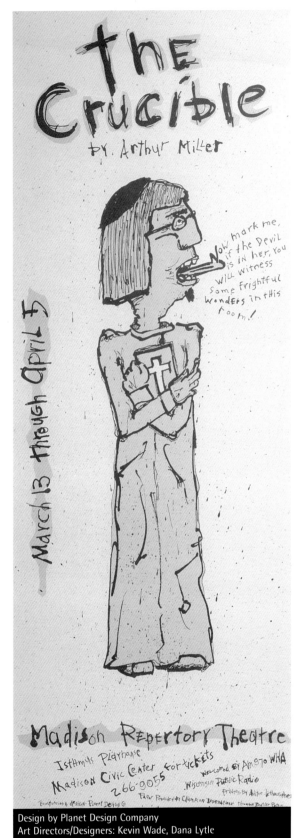

Design by Planet Design Company
Art Directors/Designers: Kevin Wade, Dana Lytle

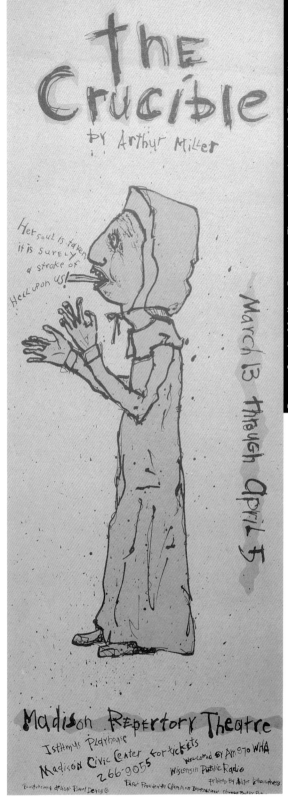

This poster for Arthur Miller's dramatic statement about the 1950s McCarthy hearings shows a deliberately crude illustration by Kevin Wade accompanied by hand-rendered letterforms that emphasize the play's emotionally charged atmosphere.

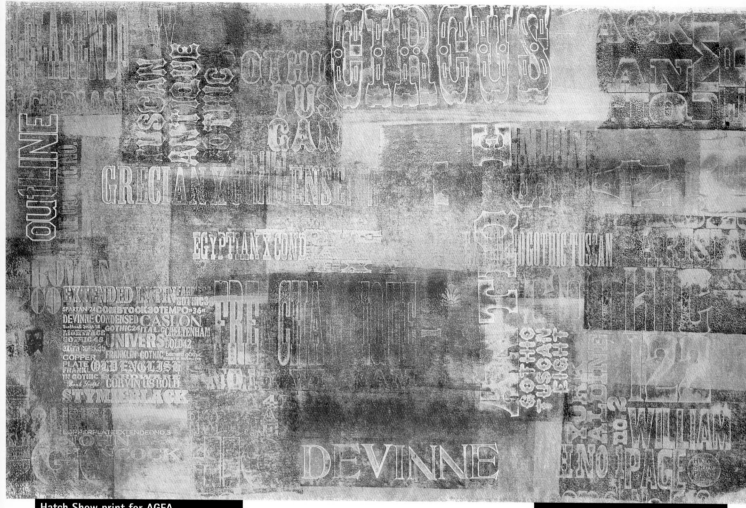

Hatch Show print for AGFA

Design by Segura, Inc.,
Printing: Hatch Show Print

Plates carved from wooden blocks printed this richly layered typographic collage. The font design intricately blends point sizes and kerning in a geometric tapestry of type; the degenerated look of the type adds authenticity.

Layouts in this issue of the Agfatype Idea Catalog use Agfa
typefaces favored by Chicago-area graphic designers and art
directors. The front and back cover of the issue, designed by
Carlos Segura and illustrator Stephen Farrel takes a ransom-note
approach, with letters photocopied and pasted down, emphasizing
the intuitive nature of the design process.

Design by Segura, Inc.
Art Director/Designer: Carlos Segura
Illustrator: Stephen Farrell

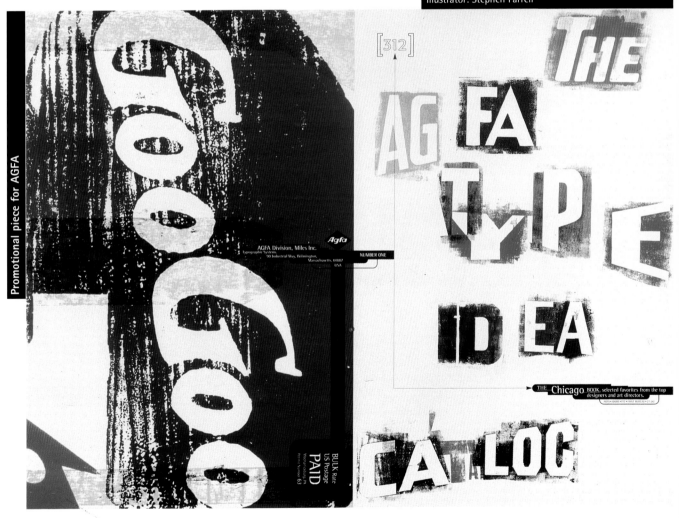

Promotional piece for AGFA

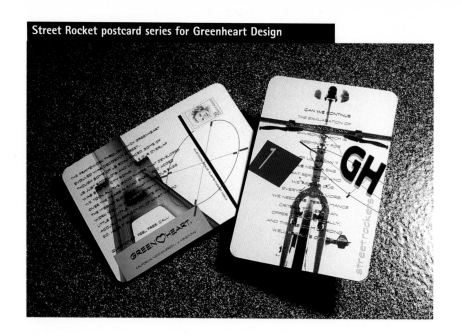

Street Rocket postcard series for Greenheart Design

These postcards for Greenheart Design promote the company's Street Rocket bicycles with photographs of bicycle details layered with text set in a friendly, open display font. A floating company logo in italic, dimensional letterforms, suggests muscle and movement.

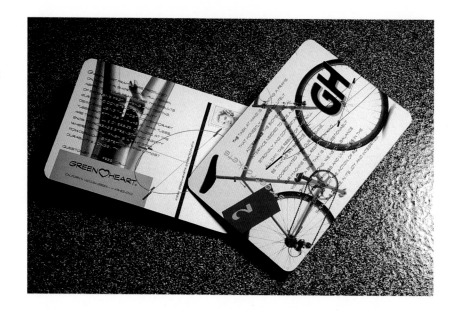

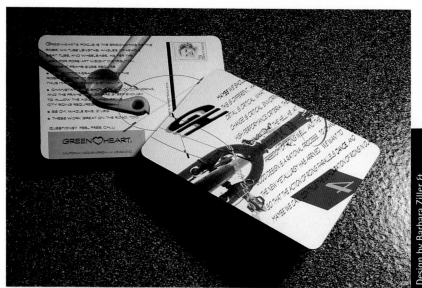

Design by Barbara Ziller &
Associates Design
Art Directors/Designers: Barbara
Ziller, Andrew Graef
Photographer: Kevin Sanchez

Design by Mires Design, Inc.
Art Director/Designer: John Ball
Illustrator: David Quattrociocchi

A twist on the caveat, "read between the lines," the message on this piece for

the Communicating Arts Group shouts out over the lines. Body text urges club

members to cast their ballot in an annual board-member election, while headline

tells them to put their money where their mouth is. It is a classic example of a

disarming typographic solution with simplicity at its core.

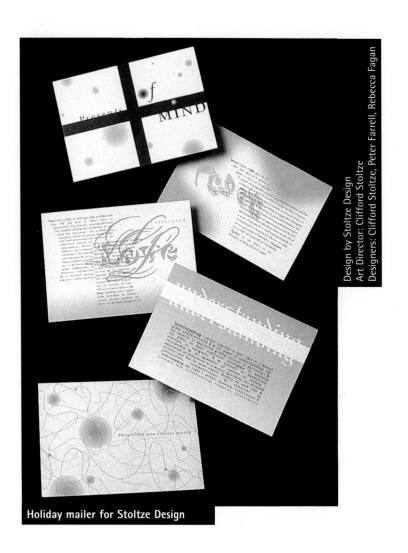

Design by Stoltze Design
Art Director: Clifford Stoltze
Designers: Clifford Stoltze, Peter Farrell, Rebecca Fagan

Holiday mailer for Stoltze Design

A holiday self-promotion by Stoltze Design in Boston featured postcards with the words *peace, love,* and *understanding*. Each postcard wove together text with the key word as a central, expressive calligraphic visual.

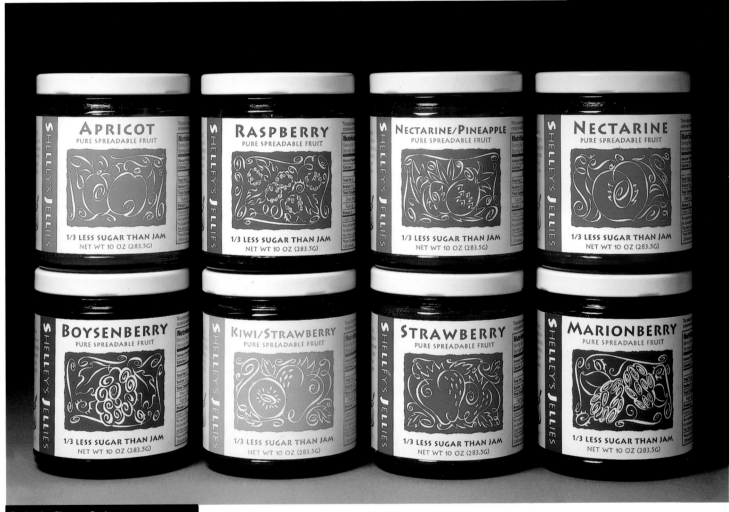

Design by Charney Design
Art Director/Designer: Carol Inez Charney
Illustrator: Kim Farrell

A clean, open and contemporary sans serif font was chosen for label copy for Shelly's Jellies. The typeface selection complements Kim Ferrell's whimsical illustration style and conveys the purity of the all-natural spreadable fruit.

Working with the theme "Expand Your Horizons" for the Western Regional
Greek Conference held in San Francisco, John Sayles used a bridge
metaphor to reflect the topic and location of the event in this promotional
brochure. The piece takes a horizontal format with letterforms spelling out
the conference title in a bridge-like configuration.

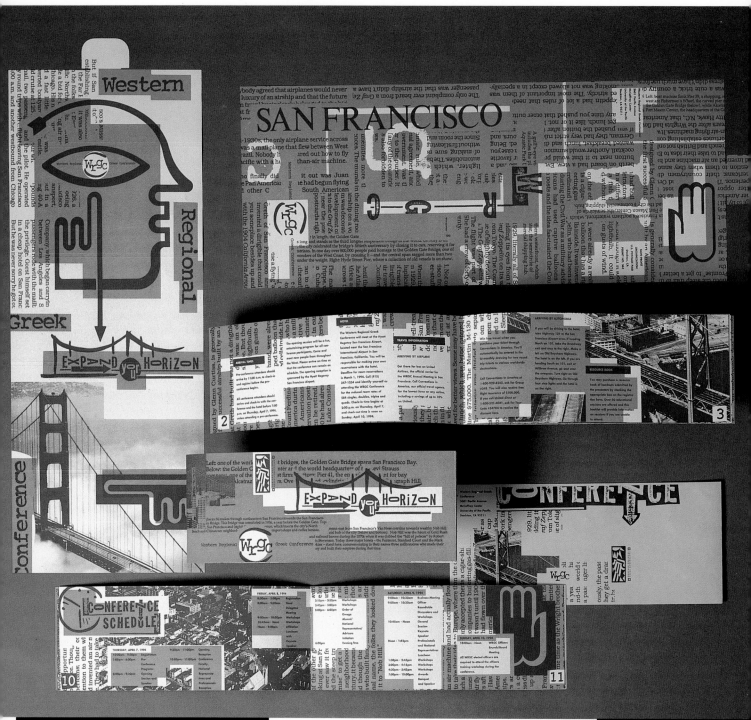

Brochure for Western Regional Greek Conference

Design by Sayles Graphic Design
Designer: John Sayles

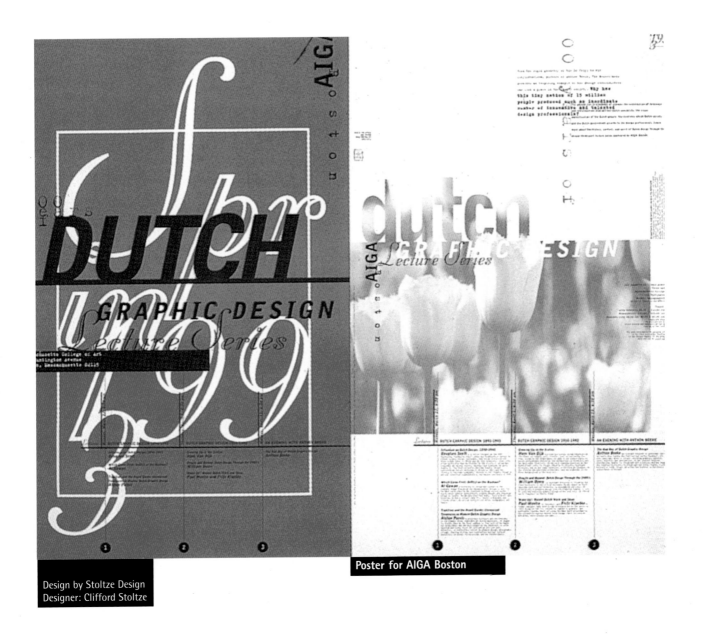

Design by Stoltze Design
Designer: Clifford Stoltze

Poster for AIGA Boston

This poster was created by Stoltze
Design in Boston to promote an AIGA
lecture series on Dutch graphic design.
Its elliptical use of a range of
contemporary typefaces layered with
photographic images reflects Holland's
rich heritage for clean, yet
experimental design.

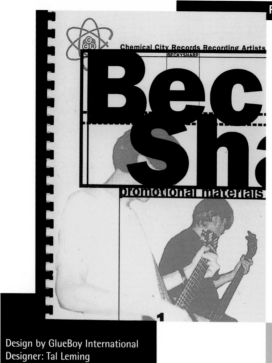

Design by GlueBoy International
Designer: Tal Leming

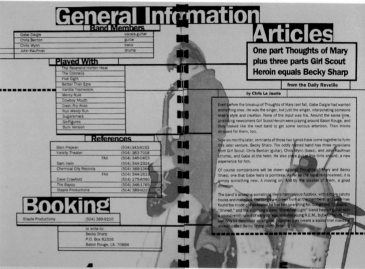

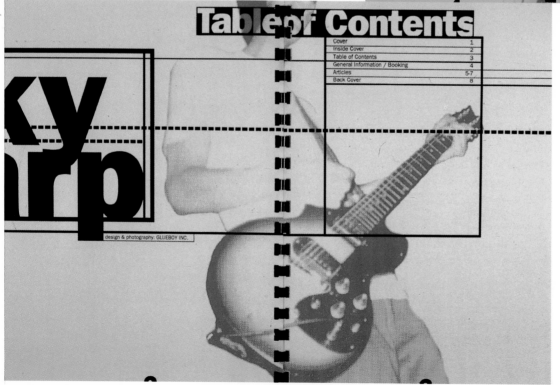

Layouts for this promotional booklet for Becky Sharp, a Chemical City Records recording artist, incorporate a rectangular grid with boldface headline type dropped out of black bars and text and callouts poured into boxes.

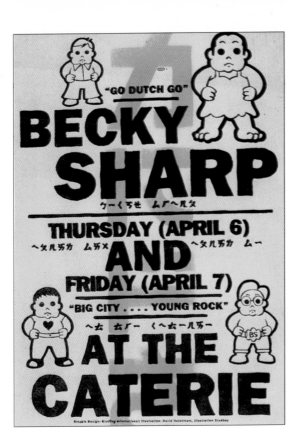

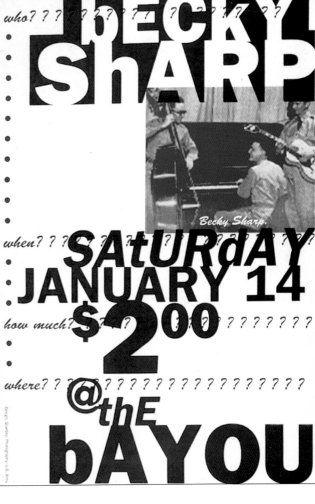

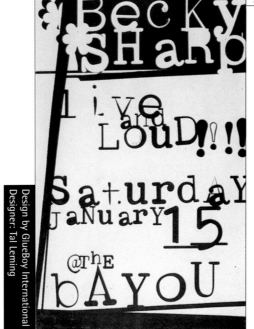

Design by GlueBoy International
Designer: Tal Leming

GlueBoy International's posters for rock musician Becky Sharp playfully mock contemporary Japanese graphics by displaying Kanji letterforms as a background and foreground element combined with garbled translations of English phrases. GlueBoy International designed these two posters to be reproduced on a copier. Text was set in various point sizes and layered for a deliberately unslick look appropriate for a rock performance.

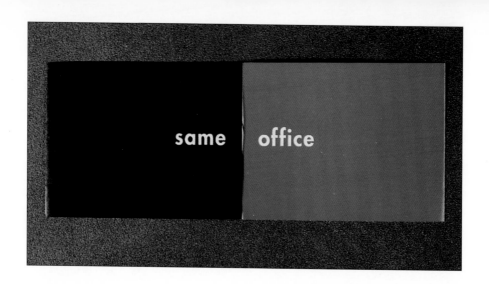

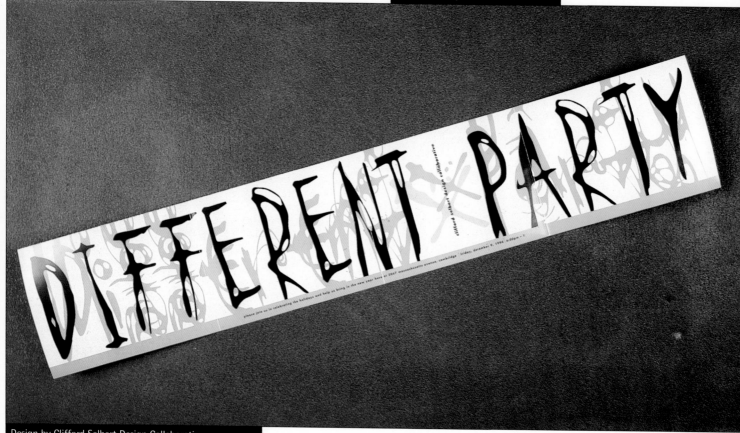

Design by Clifford Selbert Design Collaborative
Art Director: Clifford Selbert
Designers: Clifford Selbert, Jodi Singer, Nancy Brown

This invitation to a holiday party by the Clifford Selbert Design Collaborative takes full advantage of the drama that can be achieved by using two highly contrasting typestyles. The words, "same office" on the outside flaps are set in a neutral sans serif; when the "doors" are opened, the words "different party," pops out in a rough-hewn, funky display face, promising that this will be no ordinary fete.

This annual report for Anheuser-Busch Employee's Credit Union emphasizes financial strength and a sense of community with key phrases such as "working together" and "financial health" shown elliptically with portions of the letters or words missing, creating a mood matching the accompanying photographs.

Design by Kiku Obata & Company
Art Director/Designer: Pam Bliss
Photographer: Stephen Kennedy

This promotional poster by Carlos Segura for the band Counting Crows pairs an image of lead singer Adam Duritz distorted in Photoshop with type distressed on a copier.

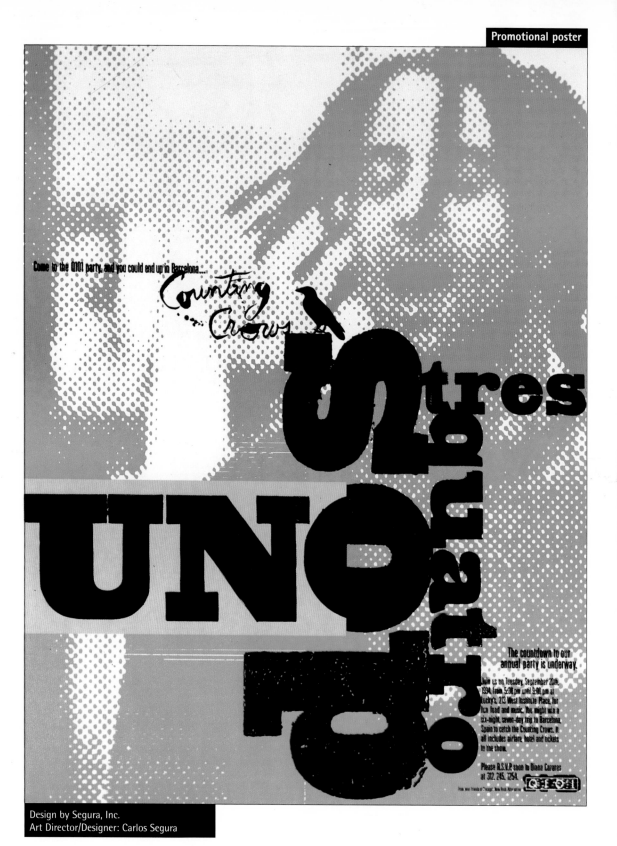

Design by Segura, Inc.
Art Director/Designer: Carlos Segura

Selected Notes 2 ZeitGuys is an interactive font project created by Aufuldish & Warinner and distributed by Emigre. Created as an "exquisite corpse," where each author picks up where the last ended, the project promotes the 126 collected illustrations that comprise the *ZeitGuys* font. The piece uses a navigational device that allows users to pass the cursor over out-of-focus images and type to make the characters pop into view.

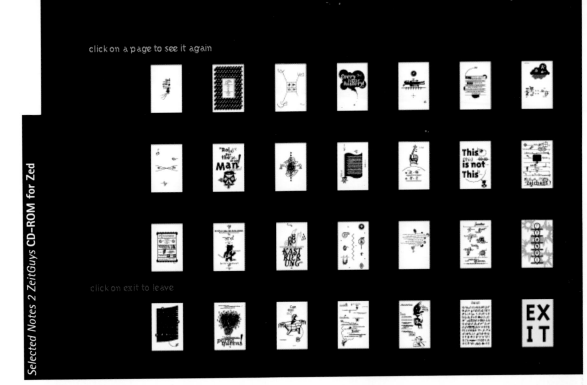

click on a page to see it again

click on exit to leave

Selected Notes 2 ZeitGuys CD-ROM for Zed

text by **Mark Bartlett**

design by **Bob Aufuldish**

images by **Eric Donelan**

Eric Donelan
statement about *the images*

Mark Bartlett
statement about *the text*

Bob Aufuldish
statement about *the design*

Selected Notes to ZeitGuys

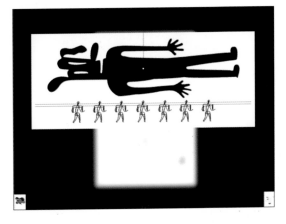

Eric Donelan

ZeitGuys is a collection of 126 images in font format which form a new poetical language to buttress the burned-out shell which is alphabetic communication.

ZeitGuys is an endless "Exquisite Corpse" with each author redefining the image-language, infusing it with particular meaning where before there was none.

Moreover, because of the prevalence of font piracy worldwide, these images will become global, and have the potential to become symbols with different meanings in different cultures. Thus ZeitGuys could be thought of as the first symbol virus to spread worldwide.

Design by Aufuldish & Warinner
Designer: Bob Aufuldish

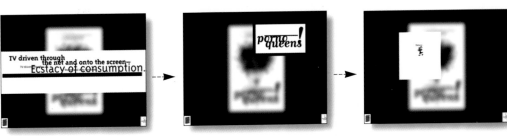

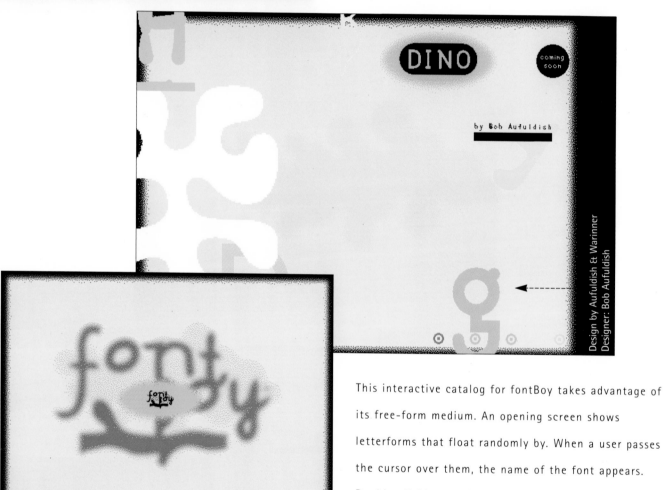

Design by Aufuldish & Warinner
Designer: Bob Aufuldish

This interactive catalog for fontBoy takes advantage of its free-form medium. An opening screen shows letterforms that float randomly by. When a user passes the cursor over them, the name of the font appears. Double-clicking sends the viewer to a screen that shows the full font family.

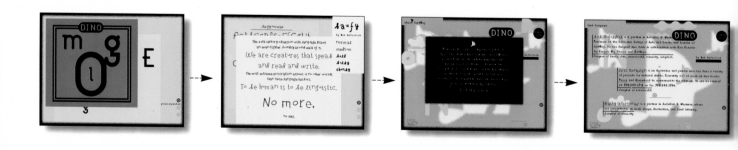

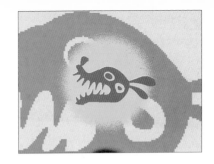

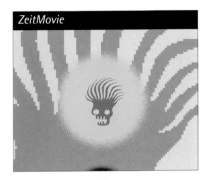

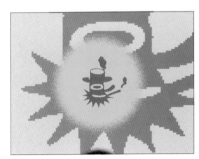

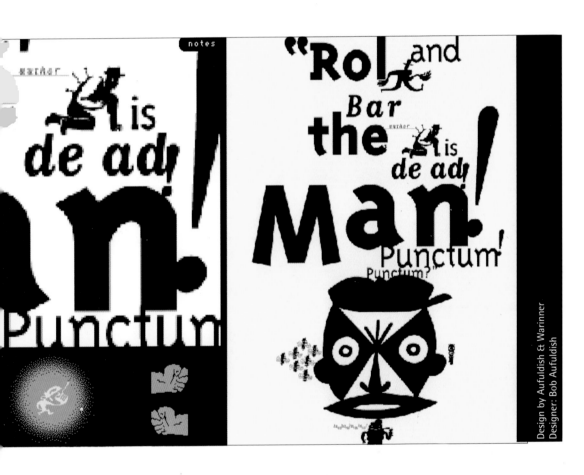

Design by Aufuldish & Warinner
Designer: Bob Aufuldish

To promote the quirky ZeitGuys font over their bulletin-board service, Emigre created *ZeitMovie*, a piece using sound and animation that makes the illustration font come to life. A shifting sequence of images from the font appears on the screen, enhanced by a sound file that constantly loops.

 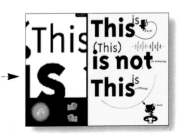

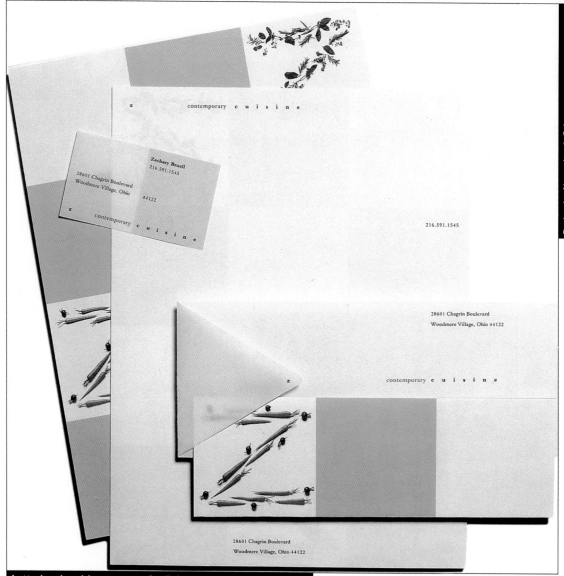

Design by Nesnadny & Schwartz
Art Directors: Joyce Nesnadny, Mark Schwartz
Designer: Joyce Nesnadny

Letterhead and logo system for Z Contemporary Graphics

The 24-piece identity program and interior graphics for Z Contemporary Cuisine by Nesnadny &

Schwartz expressively plays off the angular initial letter *Z* of owner Zachary Bruell's first name. In

printed materials, the letter *Z* is fashioned from a variety of organic materials such as leaves and

vegetables. In the restaurant's entrance, a large, decorative *Z* is created out of grapevines.

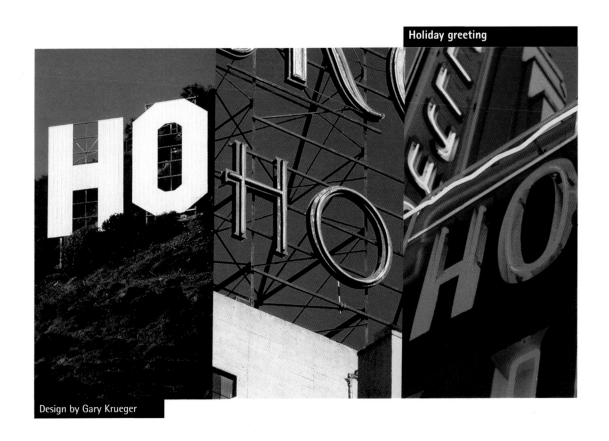

Design by Gary Krueger

Sometimes letterforms found in commercial signage can inspire a designer. Here, Gary Krueger arranged photographs of letterforms found in the landscape—most likely from hotels and the Hollywood hillside—to spell out a holiday greeting.

For these self-promotional postcards created by Stoltze Design, words related to the creative process such as "passion" and "spark" were brought to life in illustrative arrangements that enhance their emotional impact.

pas•sion \'pash-en\ n [ME fr. OF, fr. LL passion-, passio suffering, being acted upon, fr. L passus, pp. of pati to suffer — more at PATIENT] (12c) 1 often cap a : the sufferings of Christ between the night of the Last Supper and his death b : an ontario based on a gospel narrative of the Passion 2 obs : SUFFERING 3 : the state or capacity of being acted on by external agents or forces 4 a (1) : EMOTION <his ruling ~ is greed> (2) pl : the emotions as distinguished from reason **b : intense, driving or overmastering feeling or conviction <driven to paint by a ~ beyond her control>** c : an outbreak of anger 5 a : ardent affection : LOVE b : a strong liking or desire for or devotion to some activity, object or concept c : sexual desire d : an object of desire or deep interest — pas•sion•less \-les\ adj

passion

Holiday greeting cards for Stoltze Design

GK spearca; akin tooMD sparke spargan to swell] (bef. 12c)

spark

1 a : a small particle of a burning substance thrown out by a body in combustion or remaining when combustion is nearly completed
b : a hot glowing particle struck from a larger mass; esp: one heated by friction<produce a ~ by striking flint with steel> 2 a : a luminous disruptive electrical discharge of very short duration between two conductors separated by a gas (as air) b : mechanism controlling the discharge in a soark plug

3 : SPARKLE, FLASH 4 : something that sets off a sudden force <provided the ~ that helped the team to rally> 5 : a latent particle capable of growth or developing : GERM <still retains a ~ of decency>

6 : pl but sing in constr :a radio operator on a ship

Design by Stoltze Design
Art Director: Clifford Stoltze
Designers: Clifford Stoltze, Peter Farrell

Johnson & Johnson

To announce the birth of their child, designers Wayne and Susan Johnson couldn't resist co-opting a generations-old corporate mark and creating their own, lowercase version, to make their joyful statement.

& johnson

Susan & Wayne are proud to introduce the newest member in the Johnson family. Maegan Tayler, born on January 11, 1996, net.wt. 8lbs. 8oz. and length 20.5 inches.

Design by Susan Johnson
Designer/Illustrator: Wayne Johnson

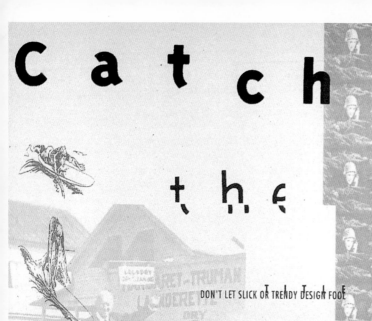

Catch the

Title Wave

DON'T LET SLICK OR TRENDY DESIGN FOOL

YOU JUMPING ON THE BANDWAGON IS OK

AS LONG AS YOU KNOW WHO'S DRIVING

wave

TITLE WAVE STUDIOS² BECAUSE SOMETIMES

THE BANDWAGON NEEDS A TUNE UP

Promotion for Title Wave Studios

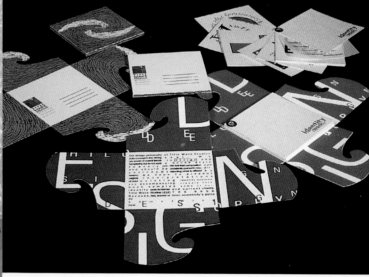

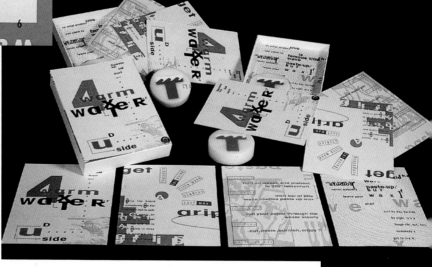

Design by Doug Bartow

To promote Title Wave Studios, designer Doug Bartow created a mailer that seized a breaking-waves theme. The piece opens with flaps shaped like curling waves with letters spelling "design" appearing large and somewhat elliptically. Type on packages containing surfboard wax continues the curling-wave motif with text arranged on curves.

A holiday card from Hornall Anderson Design Works uses die-cut letters with airbrushed edges to emulate the look of stencil letters. The flip side features a pastiche of the firm's work.

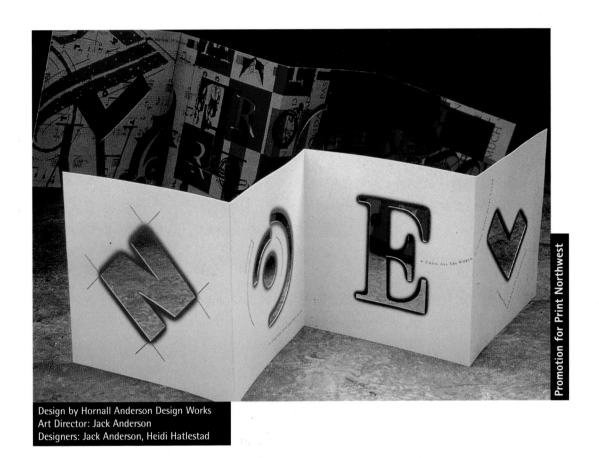

Design by Hornall Anderson Design Works
Art Director: Jack Anderson
Designers: Jack Anderson, Heidi Hatlestad

Promotion for Print Northwest

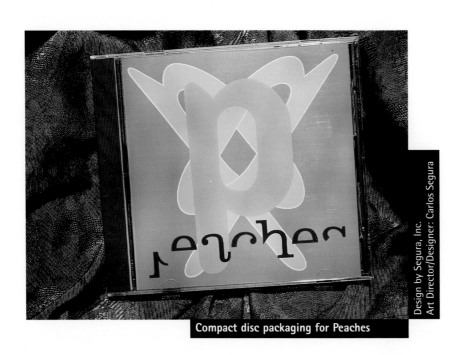

Design by Segura, Inc.
Art Director/Designer: Carlos Segura

Compact disc packaging for Peaches

The CD packaging for a
Peaches release was
designed by Carlos Segura.
The band's name appears
in an elliptical typeface
that is an exercise in how
far letterforms may be
reduced to their most
elemental form and still be
recognized and readable.

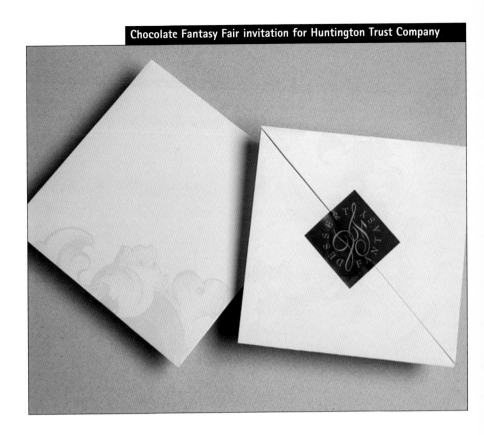

Using baroque motifs and a romantic script typeface, Rickabaugh Graphics created a luxurious mood for this invitation to the Huntington Trust Company's Chocolate Fantasy Fair.

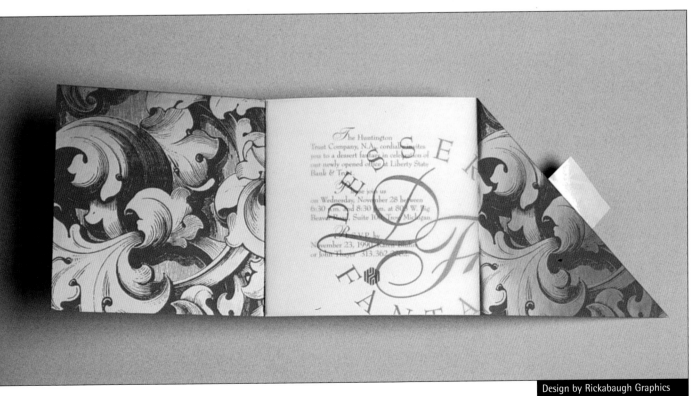

Design by Rickabaugh Graphics
Art Director: Eric Rickabaugh
Designer: Tina Zientarski

What better way to promote a children's bookstore named
Scribbles than to create shopping bags featuring stick figures
and the store logo written in an exuberant, childlike scrawl?

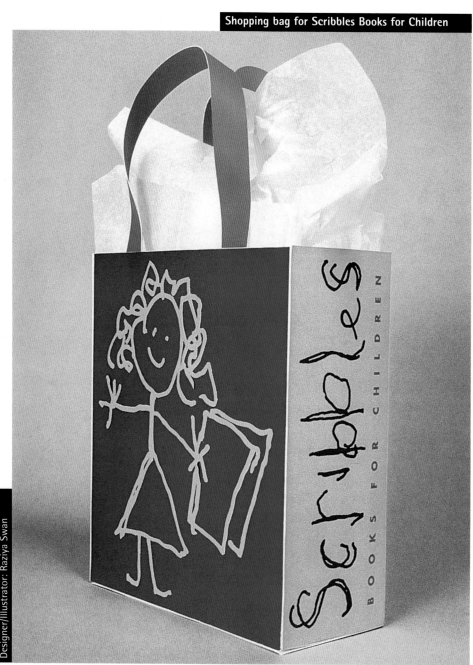

Shopping bag for Scribbles Books for Children

Design by Raziya Swan
Art Director: Alice Dreuding
Designer/Illustrator: Raziya Swan

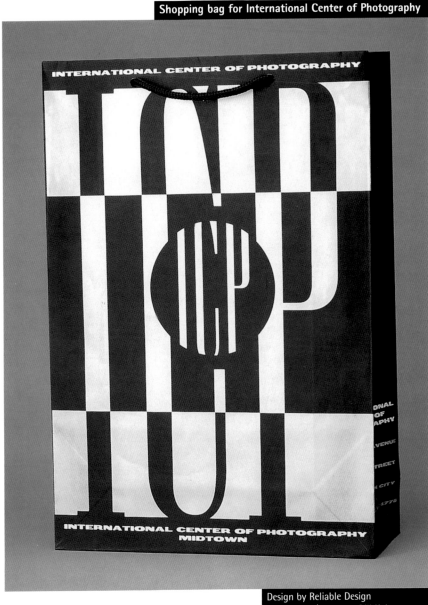

Design by Reliable Design
Art Director/Designer: Bill Kobasz

When creating an identity program for New York's
International Center of Photography, Reliable Design
embraced key elements of photography in a logo design.
This shopping bag design, for example, shows tall,
narrow initial caps that are a dramatic play of
contrasting black and white, while a central logo is
superimposed in a circle, suggesting a camera lens.

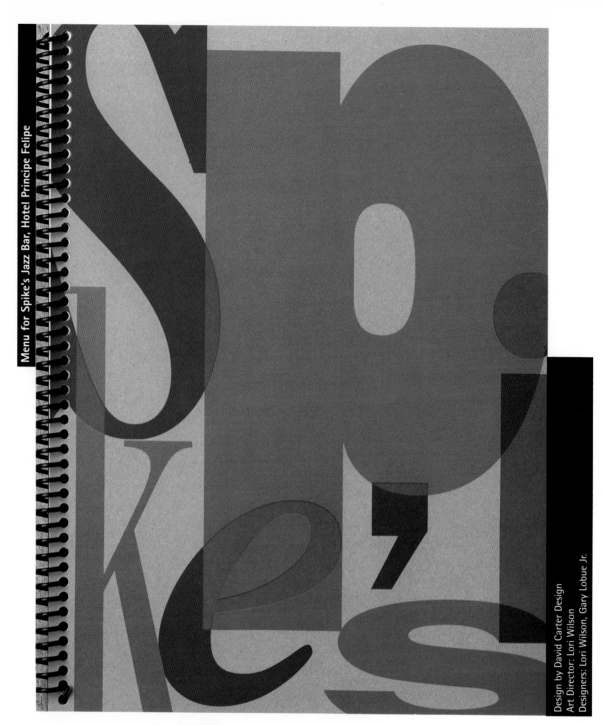

Design by David Carter Design
Art Director: Lori Wilson
Designers: Lori Wilson, Gary Lobue Jr.

Bold, aggressive type set in
various sizes and colors and
placed in a free-form, overlapping
design highlight the upbeat,
improvisational nature of this
venue, a jazz bar and restaurant.

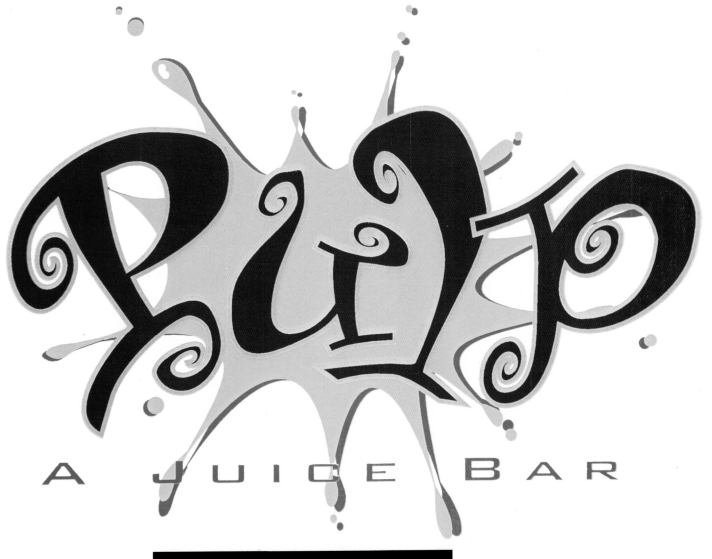

Design by Shelley Danysh Studio
Designer: Shelley Danysh

Exploding graphics and lively letterforms enhanced in Adobe Photoshop give this logo a vibrancy fitting a juice bar promoting health and energy.

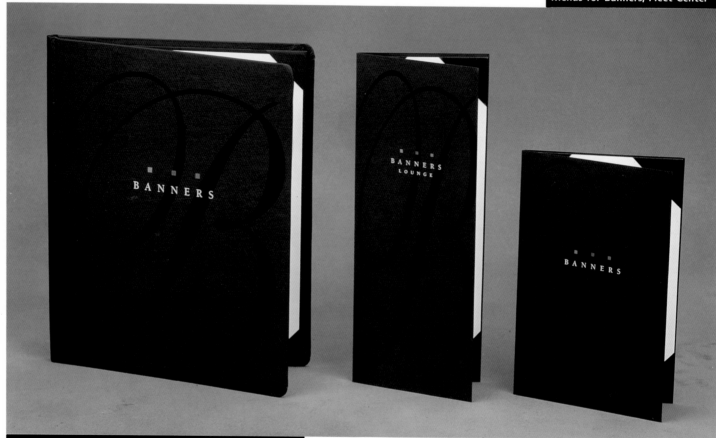

Design by Associates Design
Art Director: Chuck Polonsky
Designer: Beth Finn

The restaurant Banners was given an elegant, understated look with menu designs by Associates Design that feature a black script letter *B* printed on black linen with the establishment name dropped out in white roman letterforms for a striking contrast.

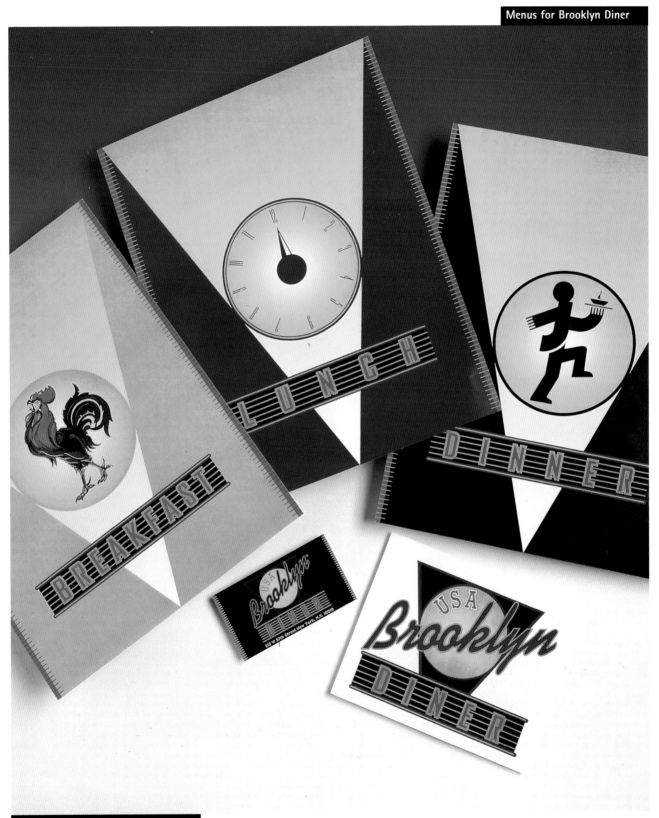

Design by Russek Advertising
Art Director/Designer: Hal Jannen
Illustrator: Martha Lewis

Menu designs for the Brooklyn Diner use a dimensional typeface
reminiscent of 1950s neon diner signs, while the restaurant's script
logo clearly pays a tribute to the much-beloved Brooklyn Dodgers.

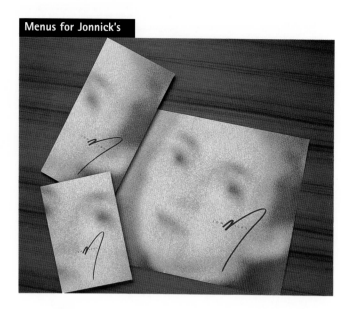

Menus for Jonnick's

Design by Sean Murphy Associates, Ltd.
Art Director/Designer: Sean Murphy
Photographer: David Bell

The flair of a handwritten signature was given to menu designs for Jonnick's Restaurant by Sean Murphy Associates. On menu covers, the restaurant name appears in a widely spaced sans serif face, with the two *N*s dashed off in ink. Menu interiors echo the logo with titles set with capital letters appearing within words, while the rules dividing subjects are accented with the signature *N*s.

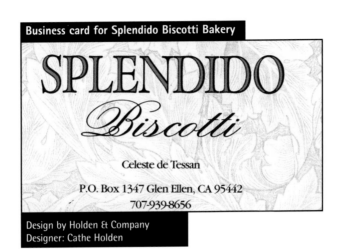

Business card for Splendido Biscotti Bakery

SPLENDIDO
Biscotti

Celeste de Tessan

P.O. Box 1347 Glen Ellen, CA 95442
707-939-8656

Design by Holden & Company
Designer: Cathe Holden

A logo design for Splendido Biscotti by Holden &

Company incorporates Italian élan with its chiseled

Roman letterforms complemented by a flourished script.

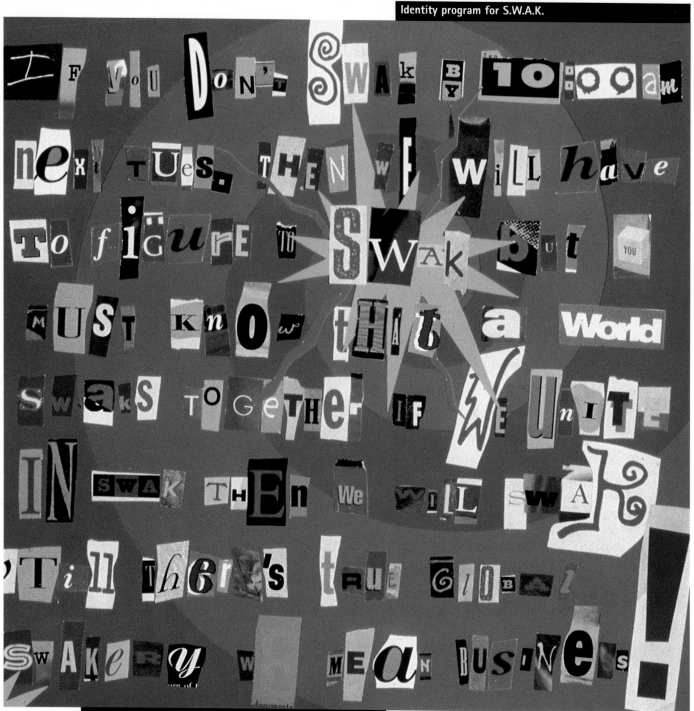

Design by Sackett Design Associates
Art Director: Mark Sackett
Designers/Illustrators: Mark Sackett, Wayne Sakamoto, James Sakamoto

When creating an identity program for S.W.A.K. (Some Wild American Kids), a product line aimed at girls 8 to 15 years old, Sackett Design Associates created graphics that incorporate a ransom-note approach, with a great variety of letterforms pasted together to form a riot of colors and styles that conveys an accessible hipness.

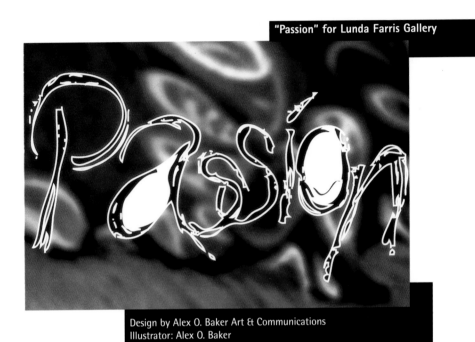

"Passion" for Lunda Farris Gallery

Design by Alex O. Baker Art & Communications
Illustrator: Alex O. Baker

To convey the heat of "passion", designer Alex O. Baker created these letterforms by hand with pen and ink, then scanned them into Adobe Photoshop. The lettering was placed into Macromedia FreeHand, autotraced, filled, and stroked. The letters appear over a image of an old medical illustration of a cross-sectioned human heart.

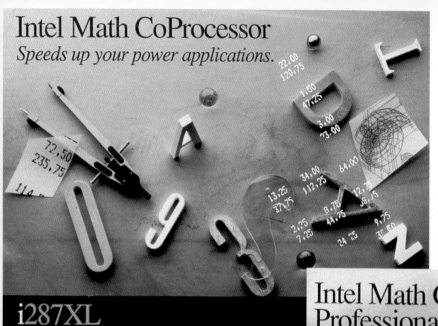

Intel Math CoProcessor
Speeds up your power applications.

i287XL

Packaging for Intel Corporation

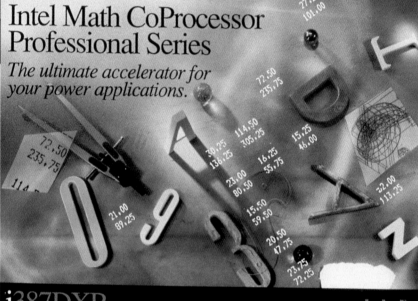

**Intel Math CoProcessor
Professional Series**
*The ultimate accelerator for
your power applications.*

i387DXP

intel

Design by Hornall Anderson Design Works
Art Directors: Jack Anderson, Julia LaPine
Designers: Jack Anderson, Julia LaPine, Denise Weir, David Bates

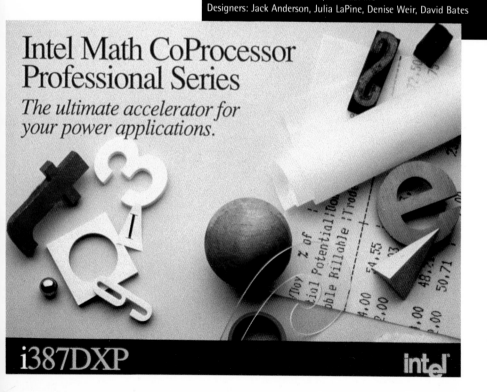

**Intel Math CoProcessor
Professional Series**
*The ultimate accelerator for
your power applications.*

i387DXP

intel

Unlike most computer-product boxes,
which typically use flatly-lit product
shots or airbrushed illustrations, this
product packaging for a coprocessor
by Intel features stylishly lit and
photographed elements of
computation, from a French curve to
marbles and metal letterforms.
Product information is set in
Garamond, an industry standard.

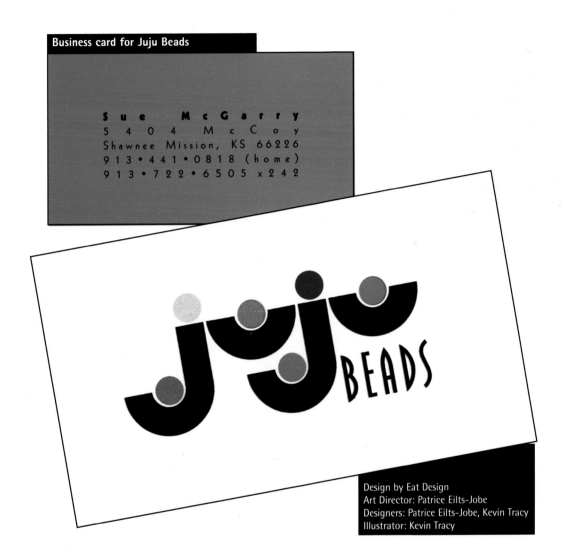

Business card for Juju Beads

Sue McGarry
5 4 0 4 M c C o y
Shawnee Mission, KS 66226
9 1 3 • 4 4 1 • 0 8 1 8 (home)
9 1 3 • 7 2 2 • 6 5 0 5 x 2 4 2

Design by Eat Design
Art Director: Patrice Eilts-Jobe
Designers: Patrice Eilts-Jobe, Kevin Tracy
Illustrator: Kevin Tracy

JuJu Beads, a craft store with a name reminiscent of
Juju-bees candies, commissioned a logo by illustrator
Kevin Tracy, filled the cups and bowls of letterforms
with bead-like circles. The result is a logo that is as
colorful and playful as the movie-house candies.

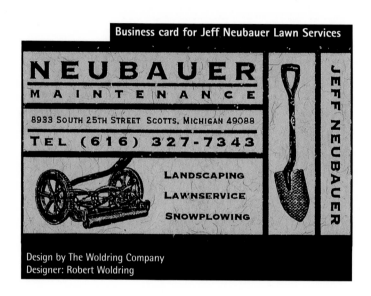

Business card for Jeff Neubauer Lawn Services

NEUBAUER
MAINTENANCE

8933 SOUTH 25TH STREET SCOTTS, MICHIGAN 49088

TEL (616) 327-7343

LANDSCAPING
LAWNSERVICE
SNOWPLOWING

JEFF NEUBAUER

Design by The Woldring Company
Designer: Robert Woldring

For Neubauer Lawn Services, the Woldring Company

created an identity that evokes early twentieth-century

Sears catalogs, with old engravings of lawn tools and

text set in a stolid serif typeface.

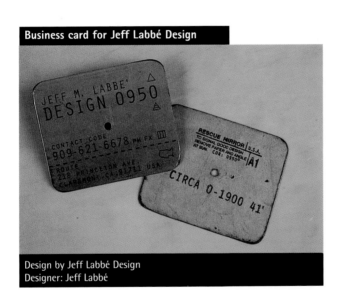

Business card for Jeff Labbé Design

Design by Jeff Labbé Design
Designer: Jeff Labbé

An army-issue rescue mirror serves as the
business card for this design studio. Text appears
in a no-nonsense, crudely spaced typeface to
mimic the institutional type on the flip slide.

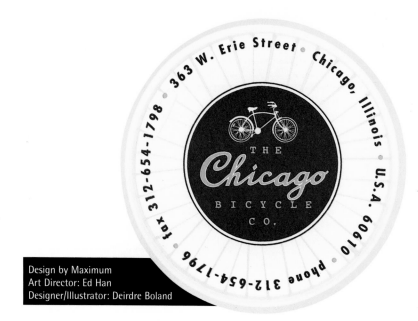

Design by Maximum
Art Director: Ed Han
Designer/Illustrator: Deirdre Boland

This business card design for the
Chicago Bicycle Co. cleverly echoes a
bicycle wheel with text wrapping
around a circular logo design. The
logo's retro script and image of a
vintage bike suggest old-fashioned
quality and service.

How do you have graphic fun with a company name that is inherently unexciting? Business cards created by Hornall Anderson Design Works for CF2GS, a marketing communications firm, playfully spills the company's moniker in colored type on a black background. Designers personalized the cards by rearranging the letters to emphasize the person's initial in the center of the card.

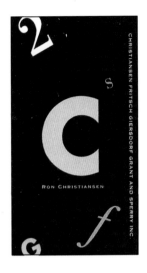

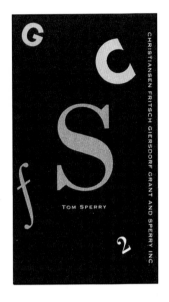

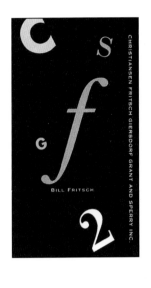

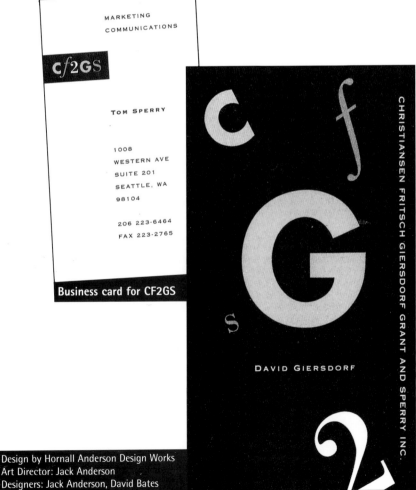

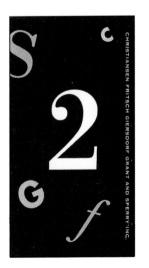

Business card for CF2GS

Design by Hornall Anderson Design Works
Art Director: Jack Anderson
Designers: Jack Anderson, David Bates

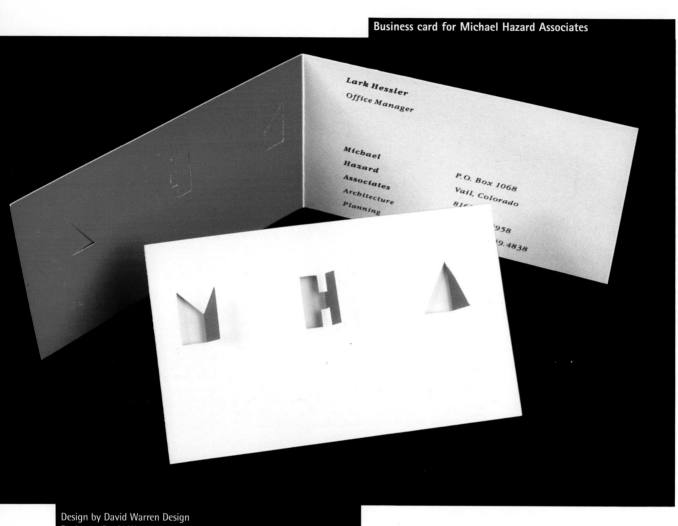

Business card for Michael Hazard Associates

Lark Hessler
Office Manager

Michael
Hazard
Associates
Architecture
Planning

P.O. Box 1068
Vail, Colorado
816...

...958

...9.4838

Design by David Warren Design
Designer: David Warren

This business card for Colorado architect Michael Hazard
effectively uses a die-cut process to create three-
dimensional initial letters to instantly and humorously
communicate the essence of his profession.

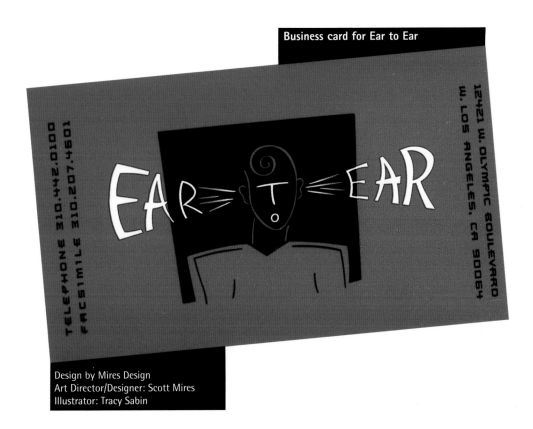

TELEPHONE 310.442.0100
FACSIMILE 310.207.4601

12421 W. OLYMPIC BOULEVARD
W. LOS ANGELES, CA 90064

EAR TO EAR

Design by Mires Design
Art Director/Designer: Scott Mires
Illustrator: Tracy Sabin

The type in this business card is practically audible: The illustrative treatment conveys the whole music listening experience, from words as sound waves to the expression on a listener's face.

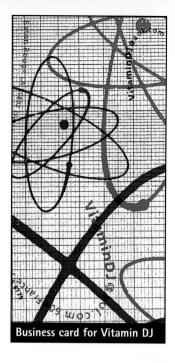

Business card for Vitamin DJ

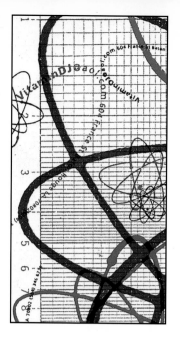

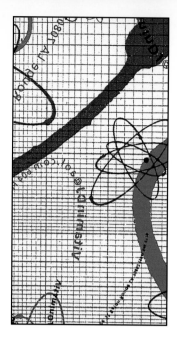

Layers of futuristic atomic models create a frenetic energy on business cards for Vitamin DJ. Design firm Paper Shrine unified copy with imagery by setting type on curved lines and weaving them in and out of spheres.

Design by Paper Shrine
Designer: Paul Dean

Business card for Gerald Geffert

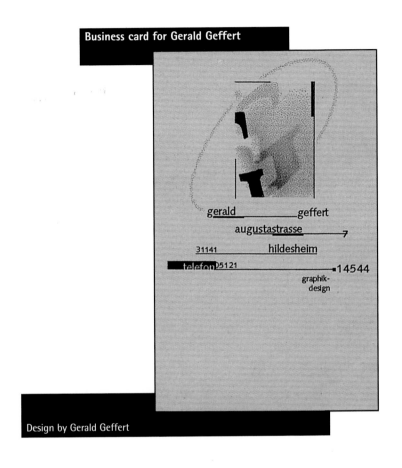

gerald_____geffert

au_gustastrasse_____7

31141_____hildesheim

telefon05121_____14544

graphik-
design

Design by Gerald Geffert

For his own business card, Gerald Geffert created an

logo based on an abstract design of his double initials:

One *G*, while seen almost in its entirety, is screened

back, while another is printed clearly but far more

abstractly, perhaps suggesting both the linear and

intuitive aspects of graphic design.

Office
5 Concourse Parkway
Suite 3100
Atlanta, Georgia 30328
☎ (404) 804-5830

Farm
Route 6
Moultrie, Georgia 31768
☎ (912) 985-1444

Ralph T. Clark

Design by Coker Golley, Ltd.
Art Directors: Jane Coker, Frank Golley
Designer: Julie Mahood

This business card for Clark Brothers Family Farms features a design reminiscent of fruit and vegetable crate labels of the 1920s. The company logo, designed in an outline font and placed on a furled ribbon, promises freshness based on generations of farming experience.

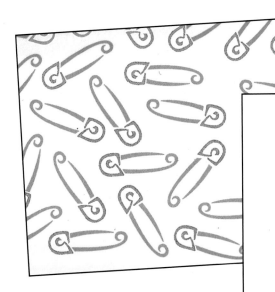

TheB rthPlace
AT SOUTHWEST GENERAL HOSPITAL

Bonnie Jimenez
Perinatal Education Coordinator

7400 Barlite • San Antonio, TX 78224 • (210) 921-8682 • Fax (210) 921-8629

Business card for The Birth Place at Southwest General Hospital

Design by The Bradford Lawton Design Group
Art Directors: Brad Lawton, Jennifer Griffith-Garcia
Designer: Brad Lawton
Illustrator: Jody Laney

Sometimes one tweak of a letter can make all the difference. Replacing the letter *I* with a diaper pin in this business card for San Antonio's Birth Place at Southwest General Hospital creates a warm and accessible feeling that is distinctly un-institutional.

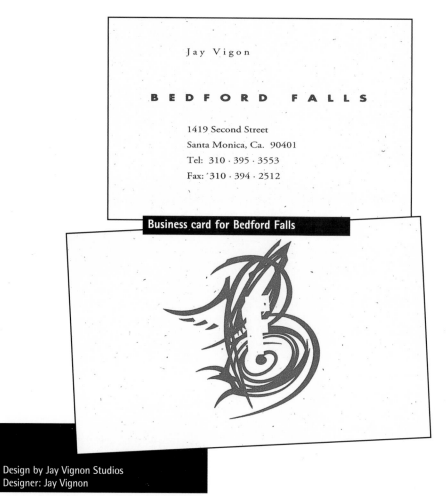

Jay Vigon

B E D F O R D F A L L S

1419 Second Street
Santa Monica, Ca. 90401
Tel: 310 · 395 · 3553
Fax: 310 · 394 · 2512

Business card for Bedford Falls

**Design by Jay Vignon Studios
Designer: Jay Vignon**

The key graphic element in this business card for West Coast production company Bedford Falls is a primitive, hand-drawn initial *B* with a drop-out cap *F* in Franklin Gothic. The drama of this logo is contrasted on the reverse side with a relatively calm type treatment of company information.

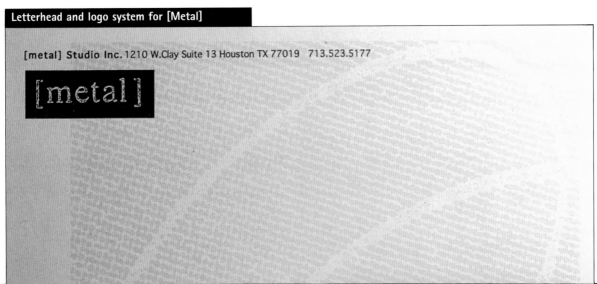

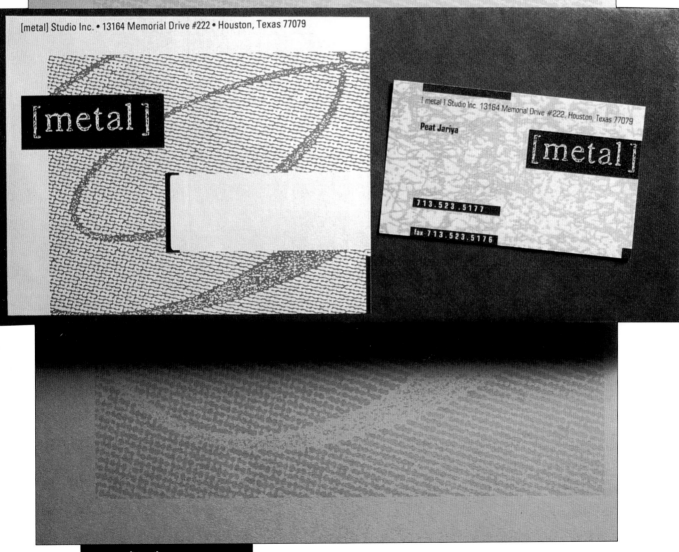

Design by [Metal]
Art Director: Peat Jariya

Art director Peat Jariya created an identity program with an industrial

look for Metal studio with distressed letters in the logo and screened

calligraphic letters printed in metallic ink.

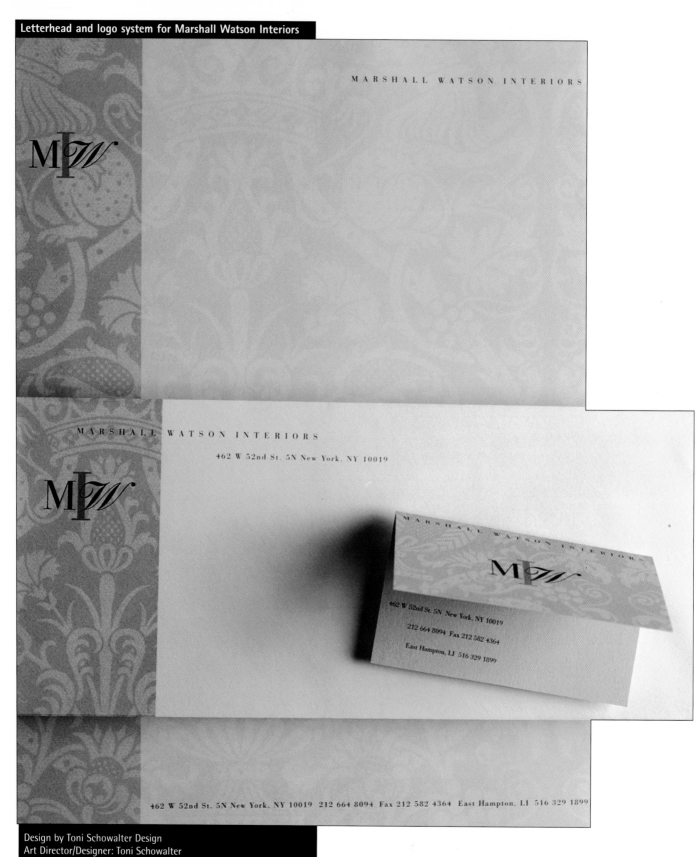

MARSHALL WATSON INTERIORS

MARSHALL WATSON INTERIORS
462 W 52nd St. 5N New York, NY 10019

462 W 52nd St. 5N New York, NY 10019
212 664 8094 Fax 212 582 4364
East Hampton, LI 516 329 1899

462 W 52nd St. 5N New York, NY 10019 212 664 8094 Fax 212 582 4364 East Hampton, LI 516 329 1899

Design by Toni Schowalter Design
Art Director/Designer: Toni Schowalter

The variety of interior styles offered by Marshall Watson Interiors is reflected in its identity program, which combines initial capitals set in serif typefaces with an italic script font.

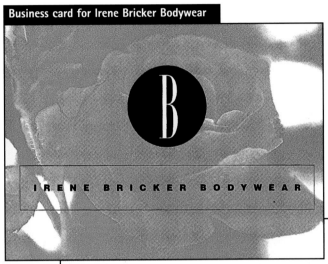

Business card for Irene Bricker Bodywear

B

IRENE BRICKER BODYWEAR

Irene Bricker

550 Union Avenue

Campbell, CA 95008

408-371-5605

Design by Melissa Passehl Design
Designer: Melissa Passehl

Elegance and simplicity are the hallmarks of
this logo treatment for Irene Bricker Bodywear.
The tall, lean initial *B* superimposed on the
screened photograph of an open rose are a far
cry from the brawny esthetic most often seen
in athletic-wear graphics.

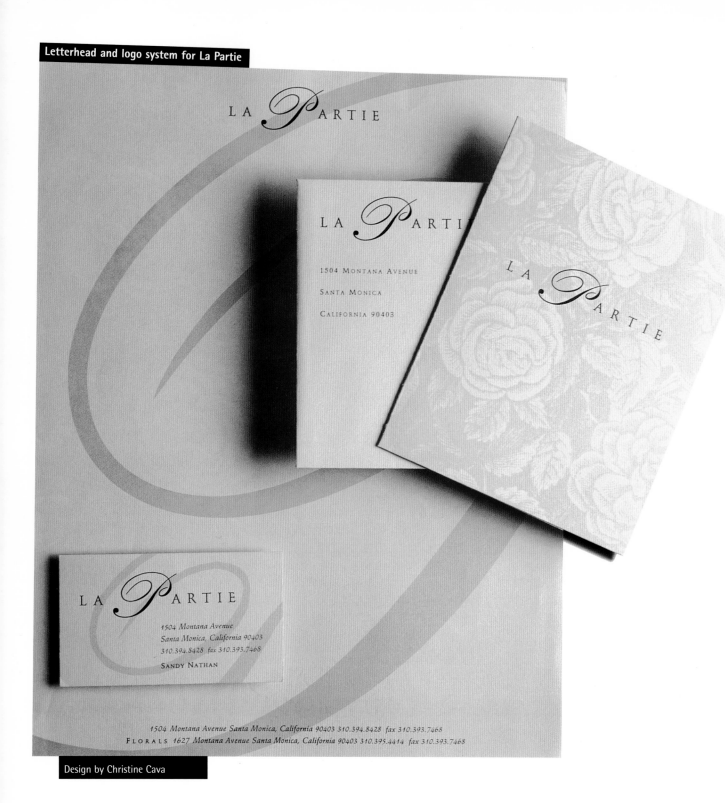

Design by Christine Cava

With a Victorian rose background and an elegant script accenting the letter *P*, the stationery system for event planner La Partie creates a fanciful mood. The flourish in the letter *P* was modified in Macromedia FreeHand.

Design by Rebeca Méndez Design
Designer: Rebeca Méndez

Through the seamless interweaving of images from installations, video, and letterpress work, this poster for an event at the American Center for Design reveals the ways Rebeca Méndez explores communication on a sensory level.

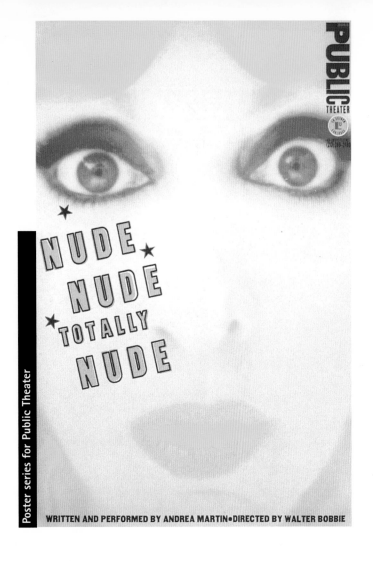

Poster series for Public Theater

NUDE NUDE TOTALLY NUDE

WRITTEN AND PERFORMED BY ANDREA MARTIN • DIRECTED BY WALTER BOBBIE

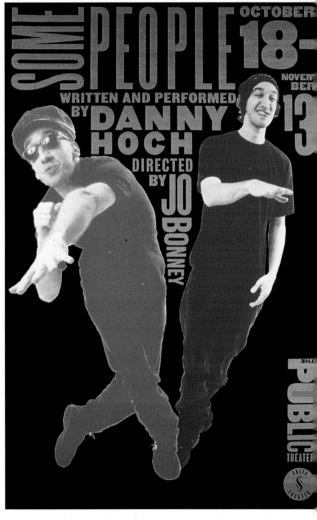

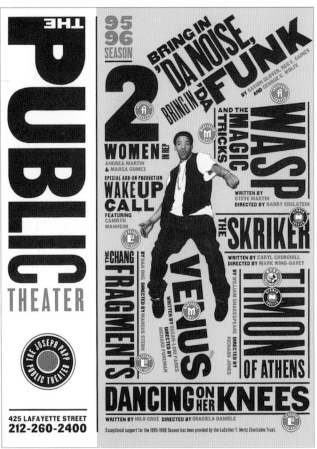

To promote the edgy productions of the Public Theater, Pentagram designers Ron Louie, Lisa Mazur, and Paula Scher created posters with bold, crammed, energetic type that virtually shouts.

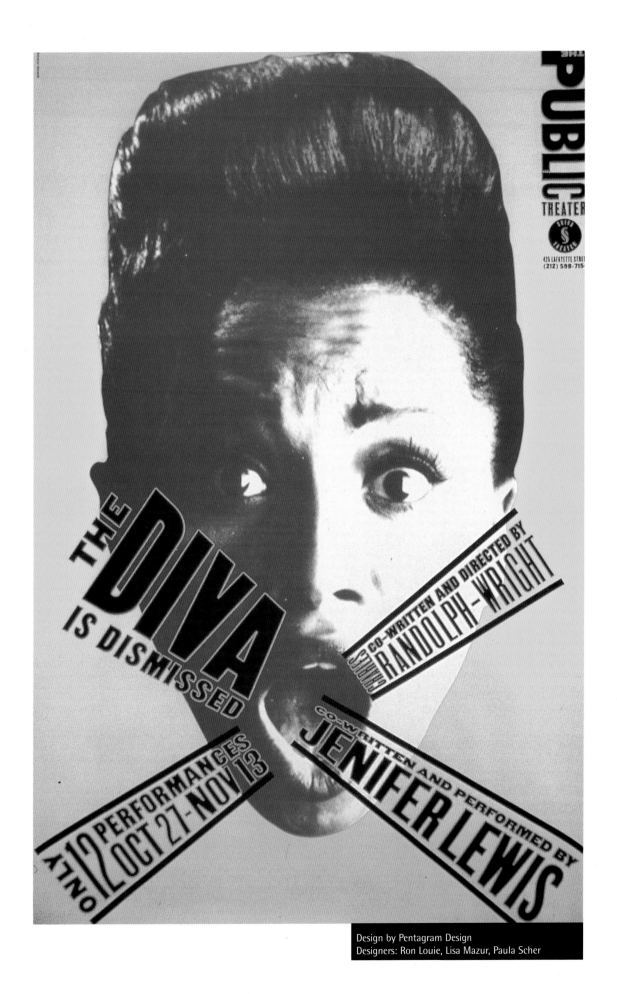

Design by Pentagram Design
Designers: Ron Louie, Lisa Mazur, Paula Scher

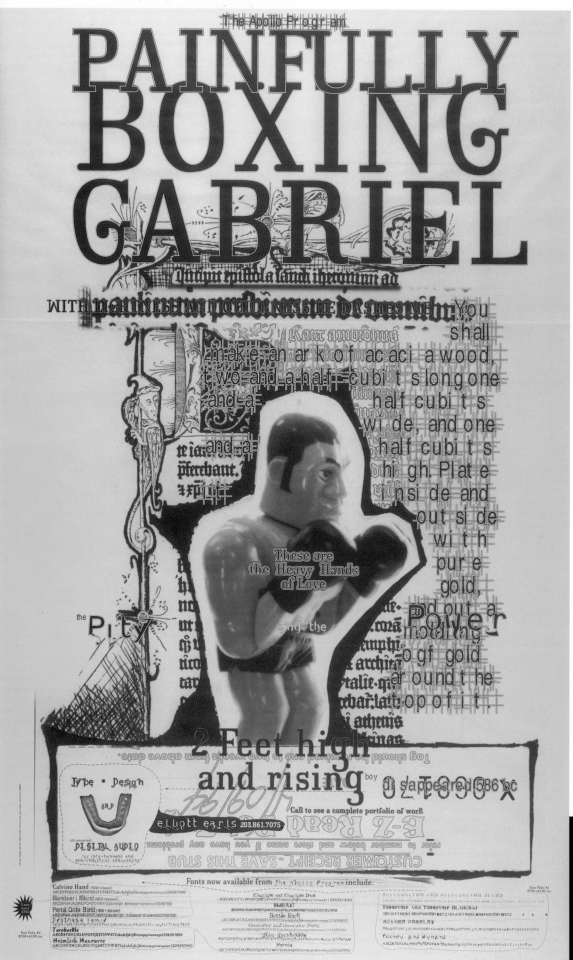

This poster promoting the typeface designs of Elliott Earls' Apollo Program creates a surreal mood by joining layer upon layer of varying font styles with images of toys and decorative elements from medieval manuscripts.

Design by The Apollo Program
Designer: Elliot Peter Earls

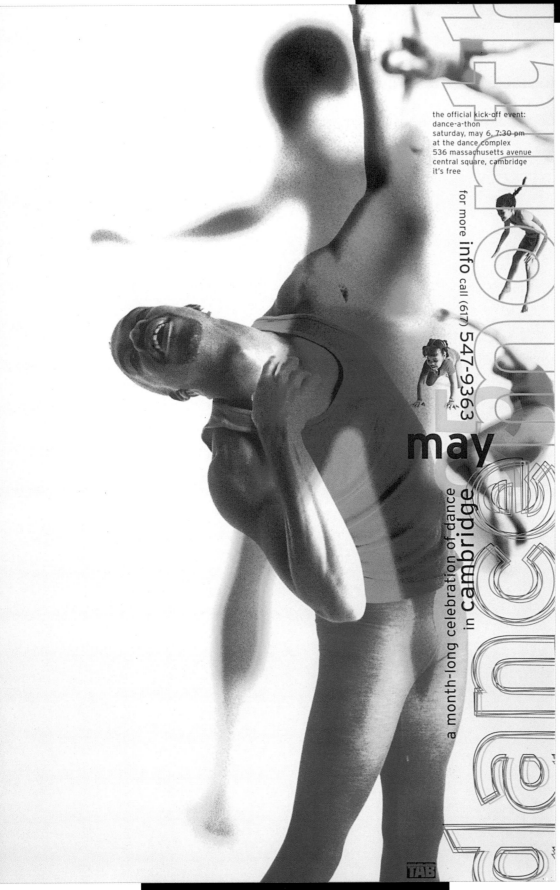

the official kick-off event:
dance-a-thon
saturday, may 6, 7:30 pm
at the dance complex
536 massachusetts avenue
central square, cambridge
it's free

for more info call (617) 547-9363

may

a month-long celebration of dance in cambridge

The colored, layered letterforms suggest movement in the headline for this poster promoting Dance Month, a spring event held in Cambridge, Massachusetts. Type lines shifting directions on the vertical grid add to the playful spirit.

Design by Visual Dialogue
Designer: Fritz Klaetke

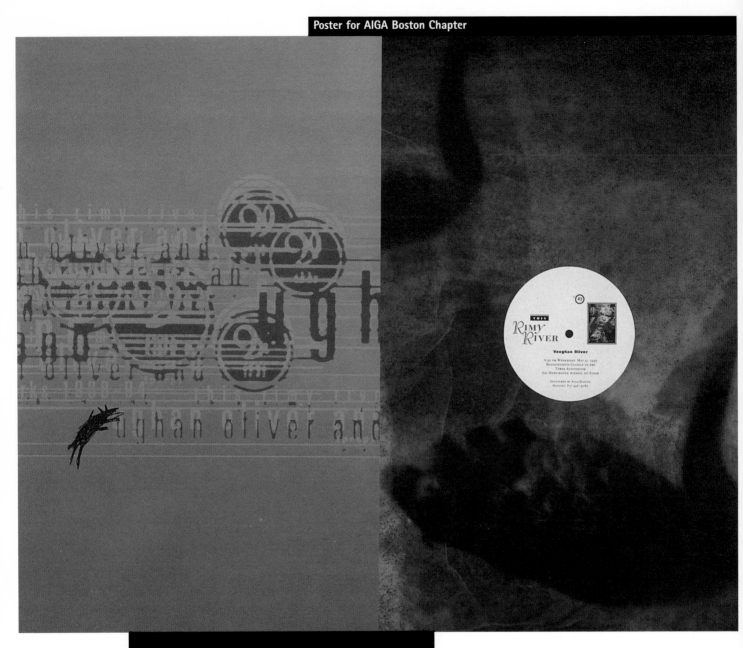

Design by Stoltze Design
Designers: Clifford Stoltze, Peter Farrell

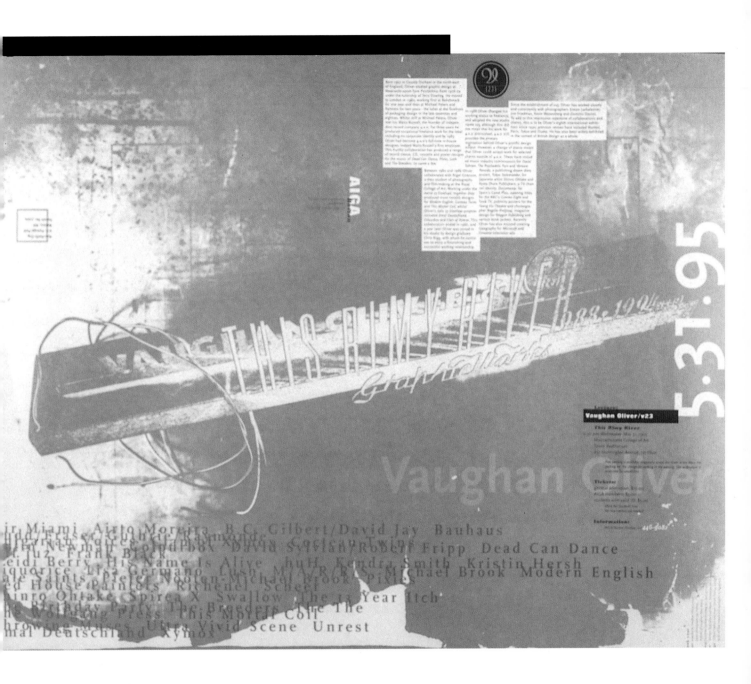

A poster promoting a talk by Vaughan Oliver uses
artwork provided by the British designer to reveal and
his characteristic blending of photography and disparate
type styles in CD cover designs.

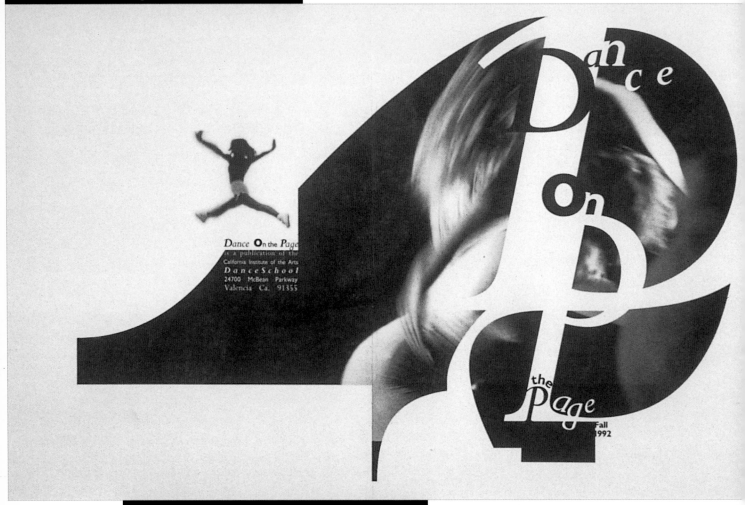

Design by Todd Childers Graphic Design
Designer: Blaine Todd Childers

Blaine Todd Childers focuses on the sensuous shapes of letterforms on a cover for Dance on the Page, a publication for the CalArts Dance School.

The soft-focus Garamond letters spelling out the eyewear manufacturer's name on this packaging at once suggest reverberation and playfully hint at myopia.

Echo Eyewear packaging for Silhouette Optical

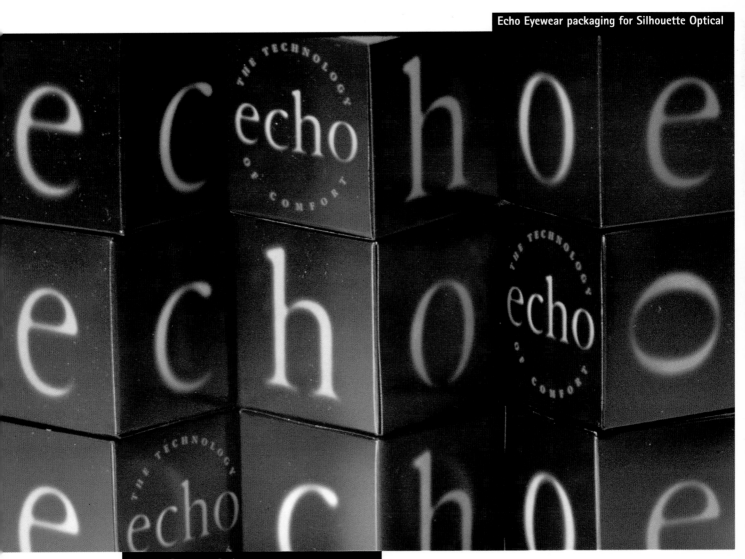

Design by Pentagram Design
Designer: Michal Gericke

Almost as if everyone from the neighborhood will keep you hot, piles of stuff together, an enormous portfolio of photographs, drawings, words, ink, and I couldn't even think of a quote (I think it was during this sequence of photos huge vile classics that things began to get difficult, it's hard to know) it's hard to know the origin of THINGs.

we would remember where those wings will fly you, for it's our secret, a child's hidden language, a history of heavenly music, of one together, or other things into songs in one voice, in another from its customary, and we could of course just retell the story in our own way, how a watcher loses himself, dissolves among shadows patching together into one lengthened out shape, a mirror of a former GATHERING. ALL OTHER WORKS. ALL OTHER HANDS. in mysterious

EXACTITUDE, spattered closeness

for everything is JUST BEGINNING.

For *Private Arts*, a literary journal, Stephen Farrell created a poem/foreword composed of bits of text taken from the journal and assembled into a montage of text and image where letterforms appear to be almost burned onto the page.

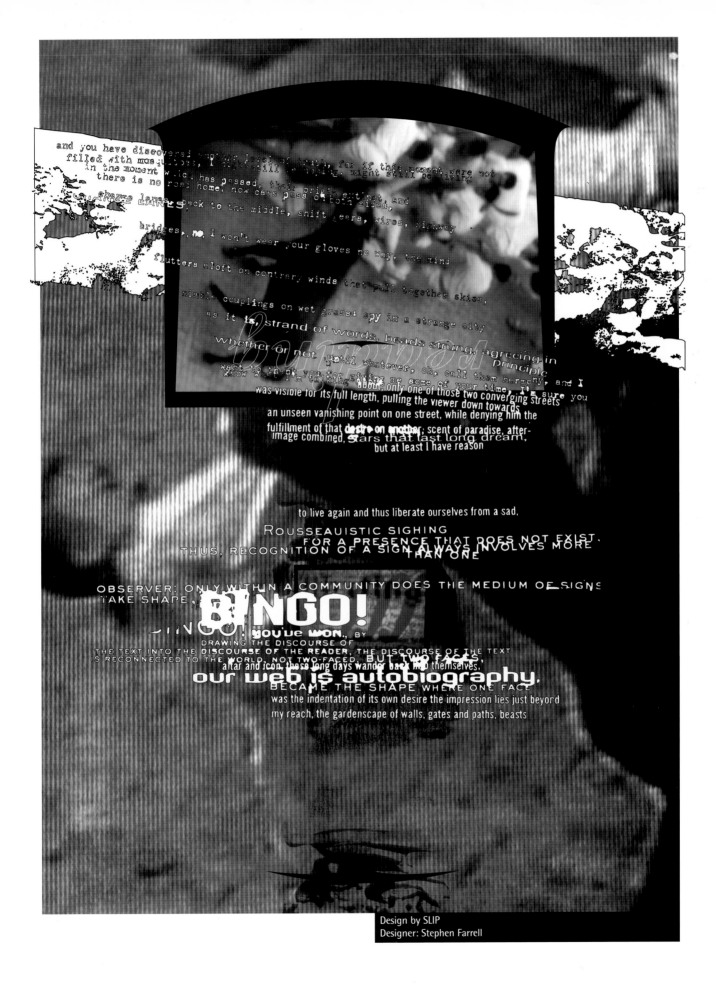

and you have discovered another level of truth, for if this moment were not
filled with masquibers, I might still be living, might still be living
in the moment which has passed, their original tint, and
there is no road home, now cars pass on both sides

change LANES back to the middle, shift gears, wires, highway
bridges, no, I won't wear your gloves no way, the mind

flutters aloft on contrary winds that pull together skies,

nimble couplings on wet grass, spy in a strange city
as it is, strand of words, beads string, agreeing in
whether or not until whatever, oh, call them harmony, and I
want to thank you for giving me some of your time, I'm sure you
know what I'm talking about, only one of those two converging streets
was visible for its full length, pulling the viewer down towards
an unseen vanishing point on one street, while denying him the
fulfillment of that desire on another, scent of paradise, after-
image combined, stars that last long dream,
but at least I have reason

to live again and thus liberate ourselves from a sad,
ROUSSEAUISTIC SIGHING
FOR A PRESENCE THAT DOES NOT EXIST.
THUS, RECOGNITION OF A SIGN ALWAYS INVOLVES MORE
THAN ONE

OBSERVER: ONLY WITHIN A COMMUNITY DOES THE MEDIUM OF SIGNS
TAKE SHAPE, BINGO!
BINGO! you've won., by
DRAWING THE DISCOURSE OF
THE TEXT INTO THE DISCOURSE OF THE READER, THE DISCOURSE OF THE TEXT
IS RECONNECTED TO THE WORLD, NOT TWO-FACED, BUT TWO FACES,
altar and icon, those long days wander back into themselves,
our web is autobiography,
BECAME THE SHAPE WHERE ONE FACE
was the indentation of its own desire the impression lies just beyond
my reach, the gardenscape of walls, gates and paths, beasts

Design by SLIP
Designer: Stephen Farrell

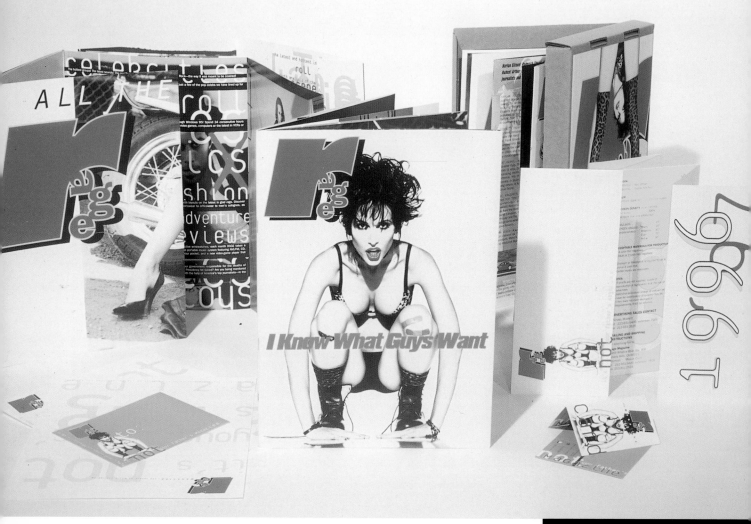

The bright, colorful type on the
press kit for this men's magazine
appeals to a young, hip audience.
Type was overlapped, stretched,
and shadowed to give a dense,
busy look.

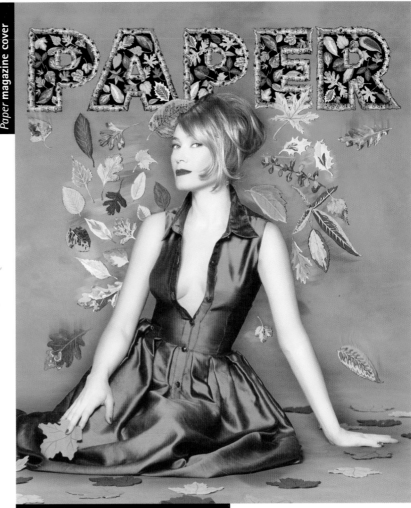

Paper magazine, the definitive magazine of New York's downtown culture, is known for the monthly permutations of its logo. For a November issue, the logo was gussied up with falling leaves and outlined in a rustic bark texture.

Design by Malcolm Turk Studios
Designers: Malcolm Turk and Bridget De Socio

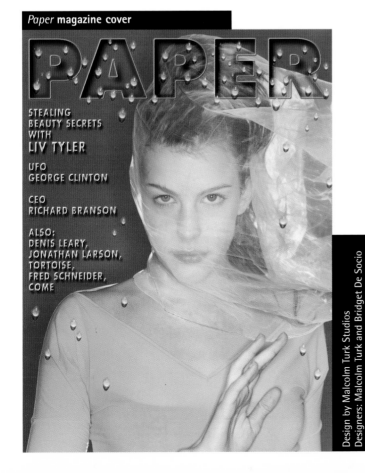

Paper **magazine cover**

STEALING
BEAUTY SECRETS
WITH
LIV TYLER

UFO
GEORGE CLINTON

CEO
RICHARD BRANSON

ALSO:
DENIS LEARY,
JONATHAN LARSON,
TORTOISE,
FRED SCHNEIDER,
COME

Design by Malcolm Turk Studios
Designers: Malcolm Turk and Bridget De Socio

Water droplets were created to fall from the logo of this issue of *Paper* magazine featuring a cover image of actress Liv Tyler. The logo's three-dimensional effect was created in Adobe Illustrator.

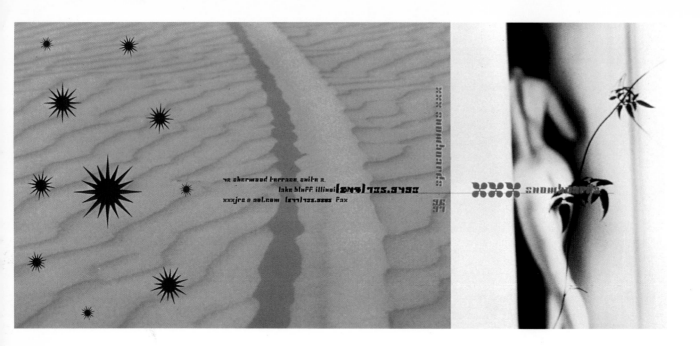

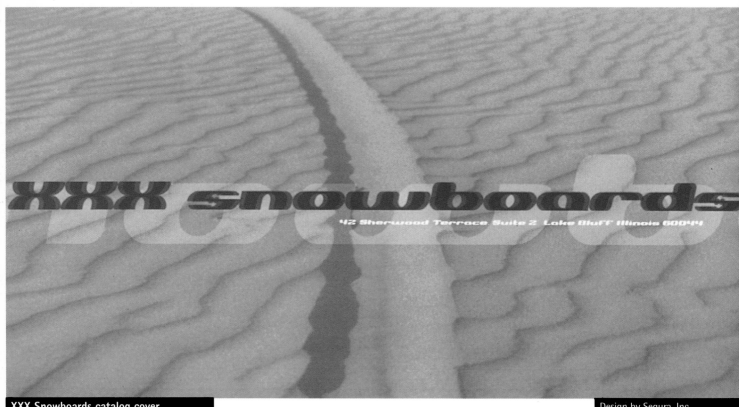

XXX Snowboards catalog cover

Design by Segura, Inc.
Designer: Carlos Segura

A wide swath is cut through powder in this
brochure for XXX Snowboards by Carlos Segura.
The image is matched thick, wide, blurry lettering
that tracks horizontally across the spread.

Design by Margo Chase Design
Designer: Margo Chase Design

Margo Chase's Vitriol, a stylized typeface inspired by medieval manuscripts, is displayed here in layers of distressed backgrounds that add texture to the ornamented letterforms.

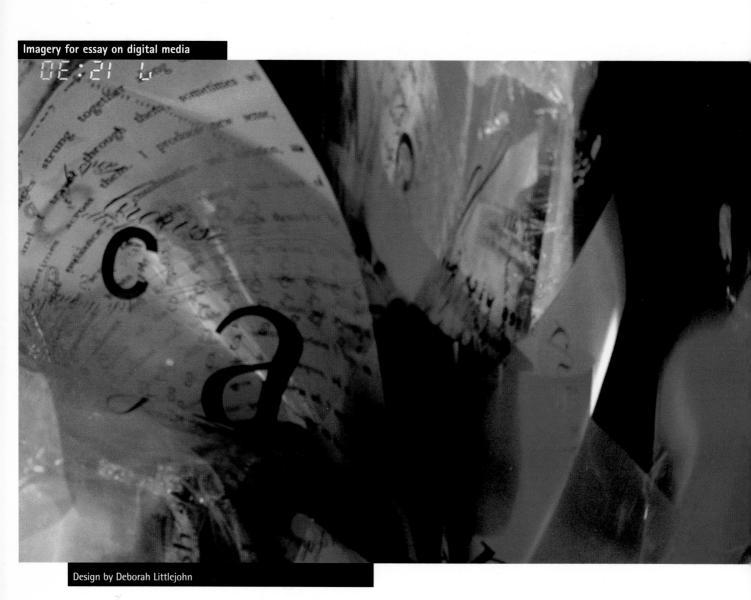

Imagery for essay on digital media

OE:21

Design by Deborah Littlejohn

An essay on digital typography, designed to be read entirely on the computer screen, is manipulated in Adobe Photoshop to enhance the fluid and dimensional aspects of the digital experience.

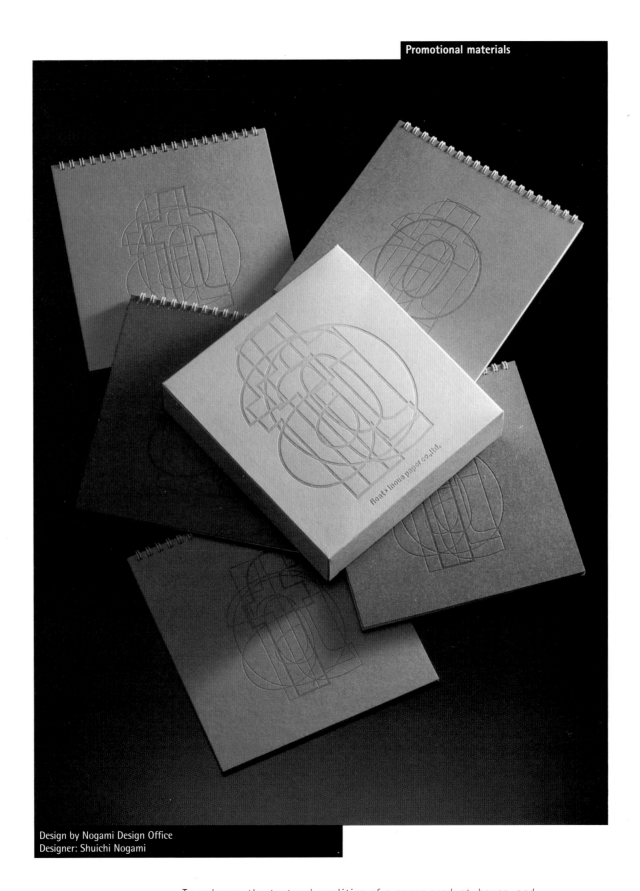

Design by Nogami Design Office
Designer: Shuichi Nogami

To enhance the textural qualities of a paper product, boxes, and

promotional materials were embossed with layers of letters set in

Franklin Gothic Demi; the process rendered inks unnecessary.

[Metal] *74*
1210 West Clay
Suite 13
Houston, TX 77019

Alex O. Baker Art &
 Communications *59*
2832 Broadway East
Seattle, WA 98102

Associates Design *54*
3177 MacArthur Boulevard
Northbrook, IL 60062

Aufuldish & Warinner *39, 40, 41*
183 The Alameda
San Anselmo, CA 94960

Barbara Ziller & Associates
 Design *28*
330 Fell Street
San Francisco, CA 94102

Buttgereit & Heinenreich
 Kommunikationsdesign *19*
Recklinghäuserstrasse 2
D-45721 Haltern am See
Germany

Charney Design *31*
1120 Whitewater Cove
Santa Cruz, CA 95062

Christine Cava *76*
826 5th Street
Santa Monica, CA 90403

Clifford Selbert Design
 Collaborative *36*
2067 Massachusetts Avenue
Cambridge, MA 02140

COY *10*
9520 Jefferson Boulevard
Culver City, CA 90232

David Carter Design *52*
4112 Swiss Avenue
Dallas, TX 75204

Deborah Littlejohn *92*
4130 Blaisdell Avenue South
Minneapolis, MN 55403

Elixir Design Co. *13*
17 Osgood Place
San Francisco, CA 94105

Gary Krueger *43*
P.O. Box 543
Montrose, CA 91021

GlueBoy International *34, 35*
P.O. Box 14857
Baton Rouge, LA 70898

HMM Communications *21*
57 Hope St.
2nd Floor
Brooklyn, NY 11211

Holden & Company *57*
804 College Avenue
Santa Rose, CA 95404

Hornall Anderson Design Works
 17, 47, 60, 65
1008 Western Avenue
Suite 600
Seattle, Washington 98104

Independent Project Press *24*
Post Box 1033
Sedona, AZ 86339

Jay Vignon Studios *72*
11853 Brookdale Lane
Studio City, CA 91604

Jeff Labbe Design *63*
218 Princeton Avenue
Claremont, CA 91711

Kiku Obata & Company *37*
5585 Pershig Avenue
Suite 24D
St. Louis, MO 63112

Laughing Dog Creative *11*
900 N. Franklin, Suite 620
Chicago, IL 60610

Malcolm Turk Studios *89*
16 Abington Square 2C
New York, NY 10014

Margo Chase Design *7, 91*
2255 Bancroft Avenue
Los Angeles, CA 90039

Maximum *64*
430 West Erie Street
Suite 406
Chicago, IL 60610

Melissa Passehl Design *75*
1215 Lincoln Avenue
Suite 7
San Jose, CA 95125

Mires Design *29, 69*
2345 Kettner Boulevard
San Diego, CA 92101

Morla Design *8, 20*
463 Bryant Street
San Francisco, CA 94107

Muller & Company *16, 18*
4739 Belleview
Kansas City, MO 64112

Nesnadny & Schwartz *42*
10803 Magnolia Drive
Cleveland, OH 44106

Nogami Design Office *93*
5-7-14-103, Nishinakajima
Yodogawa-ku, Osaka 532
Japan

Paper Shrine *68*
604 France Street
Baton Rouge, LA 70802

Penn State Design Practicom *12*
110 Patterson Building
University Park, PA 16802

Pentagram Design *22, 23, 78-79, 85*
204 Fifth Avenue
New York, NY 10010

Planet Design Company *25*
William Street
Madison, WI 53703

Raziya Swan *50*
5123 Puslaksi Avenue
Philadelphia, PA 19144

Rebeca Méndez Design *77*
Those People
1023 Garfield Avenue
South Pasadena, CA 91030

Rickabaugh Graphics *49*
384 W. Johns Towns Road
Gahanna, OH 43203

Russek Advertising *55*
1500 Broadway
24th Floor
New York, NY 10036

Sackett Design Associates *58*
2103 Scott Street
San Francisco, CA 94115-2120

Sayles Graphic Design *6, 32*
308 Eighth Street
Des Moines, IA 50309

Schmeltz & Warren *15*
74 Sheffield Road
Columbus, OH 43214-2541

Sean Murphy Associates, Ltd. *56*
505-H South Cedar Street
Charlotte, NC 28202

Segura, Inc. *26, 27, 38, 48, 90*
1110 N. Milwaukee Avenue
Chicago, IL 60622

Shelley Danysh Studio *53*
8940 Krewston Road, #107
Philadelphia, PA 19115

SLIP *86-87*
4820 North Seeley Avenue
Floor 3
Chicago, IL 60625

Stoltze Design *30, 33, 44, 82*
49 Melcher Street
Boston, MA 02210

Studio International *9*
Buconjiceva, 43
41000 Zagreb
Croatia

Susan Johnson *45*
2347 Materhorn Road
Dallas, TX 75228

The Apollo Program *80*
82 East Elm Street
Greenwich, CT 06830

The Bradford Lawton Design Group *70*
719 Avenue E
San Antonio, TX 78215

Todd Childers Graphic Design *84*
130 North Grove Street
Bowling Green, OH 43402

Toni Schowalter Design *74*
1133 Broadway
New York, NY 10010

Urban Outfitters *14*
1809 Walnut
Philadelphia, PA 19103

Visual Dialogue *81*
429 Columbus Avenue # 1
Boston, MA 02116